David Earle Anderson
Marlin House - 1991

D0953127

KEEPING A RENDEZVOUS

Also by John Berger

* *Available from Pantheon*

KEEPING A RENDEZVOUS

JOHN BERGER

PANTHEON BOOKS NEW YORK

Copyright © 1991 by John Berger

All rights reserved under International and Pan-American Copyright Conventions.
Published in the United States by Pantheon Books, a division of Random House, Inc., New York, and simultaneously in Canada by Random House of Canada Limited, Toronto.

Library of Congress Cataloging-in-Publication Data

Berger, John.
Keeping a rendezvous / by John Berger.
p. cm.
1. Art—Psychology. I. Title.
N71.B399 1991
701'.15—dc20 91-52651
ISBN 0-679-40632-8

Book Design by Anne Scatto
Manufactured in the United States of America
First American Edition

ACKNOWLEDGEMENTS

The essays in this work were originally published as follows:

Miners, first printed in an exhibition catalogue of *Paintings and Drawing by Knud and Solwei Stampe*. The Cleveland Gallery, Middlesbrough, England, 1989.

Ev'ry Time We Say Goodbye, first published in a slightly modified version in *Expressen*, Stockholm, November 3, 1990.

That Which Is Held, first published in the *Village Voice*, April 13, 1982.

A *Load of Shit*, first published as *Muck and Its Entanglements* in *Harper's Magazine*, May 1989.

Her Secrets, now titled *Mother*, first published in *Threepenny Review*, Summer 1986.

A *Story for Aesop*. Part of this text was first published in *Granta*, no. 21, Spring 1986, and another part in the *Village Voice Literary Supplement*, April 1986.

Imagine Paris, first published in *Harper's Magazine*, January 1987.

acknowledgements

A *Kind of Sharing*, first published in the *Guardian*, November 23, 1989.

Christ of the Peasants, first published by the Arts Council of Great Britain for the exhibition *Pilgrims: Photographs by Marketa Lustacova*, 1985.

A *Professional Secret*, first published in *New Society*, December 18, 1987.

One Bear, first published in *Socialist Challenge*, December 14, 1978.

Ape Theatre, first published in *Tages-Anzeiger*, November 9/10, 1990.

Infancy, first published in the *Guardian*, September 21, 1990.

The Opposite of Naked, first published as *Nakedness Veiled with Paint* in *Harper's Magazine*, December 1985.

A *Household*, first published in *New Statesman & Society*, July 15, 1988.

Drawing on Paper, first published as *To Take Paper, to Draw* in *Harper's Magazine*, September 1987.

Erogenous Zone, previously published in *El Pais*, April 8, 1988.

Lost Off Cape Wrath, first published in *Threepenny Review*, Winter 1988.

A *Different Answer*, first published in *Tages-Anzeiger*, May 5/6, 1989.

Keeping a Rendez-Vous, now titled *The Soul and the Operator*, first published in *Expressen*, March 19, 1990.

FOR BEVERLY

CONTENTS

IX

contents

KEEPING A RENDEZVOUS

NOTE TO THE READER

I TRAVEL to places. I live the years. This is a book about keeping rendezvous. (The ones I failed to keep are another story.) Each account begins with an image which conjures up something of where the meeting took place. Some would not be easy to find on a map, others would be. All of them, of course, have been visited by other travellers. I hope readers too will find themselves saying: I've been here. . . .

MINERS

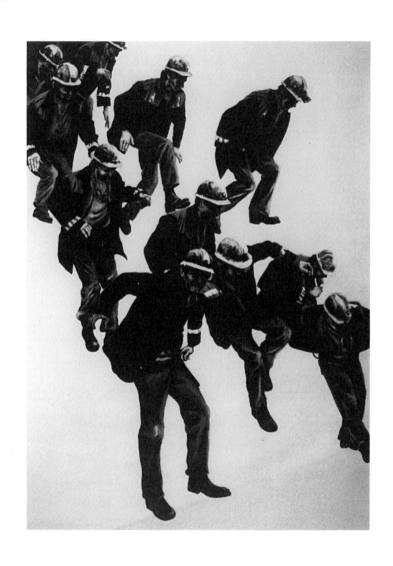

BRITISH MINERS. PAINTING BY KNUD STAMPE.

6

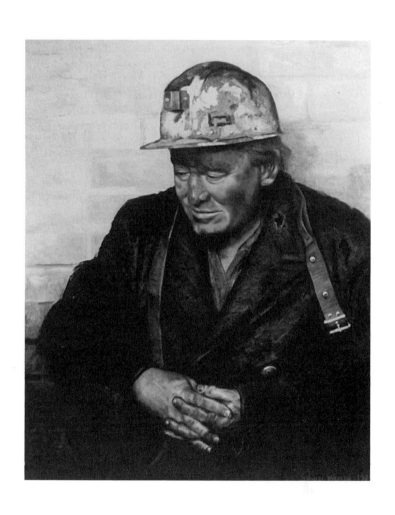

MINER. PAINTING BY SOLWEI STAMPE.

7

WHEN THE JUST CAUSE is defeated, when the courageous are humiliated, when men proven at pit-bottom and pit-head are treated like trash, when nobility is shat upon, and the judges in court believe lies, and slanderers are paid to slander with salaries which might keep alive the families of a dozen miners on strike, when the Goliath police with their bloody truncheons find themselves not in the dock but on the Honour's List, when our past is dishonoured and its promises and sacrifices shrugged off with ignorant and evil smiles, when whole families come to suspect that those who wield power are deaf to reason and every plea, and that there is no appeal anywhere, when gradually you realize that, whatever words there may be in the dictionary, whatever the Queen says or parliamentary correspondents report, whatever the system calls itself to mask its shamelessness and egoism, when gradually you realize that They are out to break you, out to break your inheritance, your skills, your communities, your poetry, your clubs, your home and, wherever possible, your bones too, when finally people realize this, they may also hear, striking in their head, the hour of assassinations, of justified vengeance. On sleepless nights during the last few years in Scotland and South Wales, Derbyshire and Kent, Yorkshire, Northumberland and Lancashire, many, as they lay reflecting on their beds, heard, I am sure, this hour striking. And nothing could be more human, more tender than such a pro-

posed vision of the pitiless being summarily executed by the pitiful. It is the word "tender" which we cherish and which They can never understand, for they do not know what it refers to. This vision is occurring all over the world. The avenging heroes are now being dreamt up and awaited. They are already feared by the pitiless and blessed by me and maybe by you.

I would shield any such hero to my fullest capacity. Yet if, during the time I was sheltering him, he told me he liked drawing, or, supposing it was a woman, she told me she'd always wanted to paint, and had never had the chance or the time to do so, if this happened, then I think I'd say: Look, if you want to, it's possible you may achieve what you are setting out to do in another way, a way less likely to fall out on your comrades and less open to confusion. I can't tell you what art does and how it does it, but I know that often art has judged the judges, pleaded revenge to the innocent and shown to the future what the past suffered, so that it has never been forgotten. I know too that the powerful fear art, whatever its form, when it does this, and that amongst the people such art sometimes runs like a rumour and a legend because it makes sense of what life's brutalities cannot, a sense that unites us, for it is inseparable from a justice at last. Art, when it functions like this, becomes a meeting-place of the invisible, the irreducible, the enduring, guts, and honour.

EV'RY TIME WE SAY GOODBYE

(For Tamara and Tilda and Derek J.)

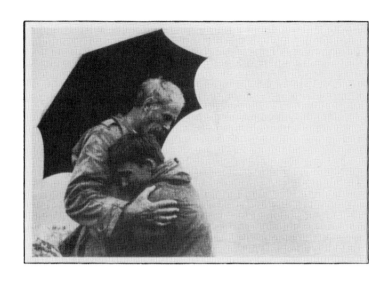

STILL FROM FREDI MURER'S FILM *HÖHENFEUER*.

11

FILM WAS INVENTED a hundred years ago. During this time people all over the world have travelled on a scale that is unprecedented since the establishment of the first towns, when the nomads became sedentary. One might immediately think of tourism: business trips too, for the world market depends upon a continual exchange of products and labour. But, mostly, the travelling has been done under coercion. Displacements of whole populations. Refugees from famine or war. Wave after wave of emigrants, emigrating for either political or economic reasons but emigrating for survival. Ours is the century of enforced travel. I would go further and say that ours is the century of disappearances. The century of people helplessly seeing others, who were close to them, disappear over the horizon. "Ev'ry Time We Say Goodbye"—as immortalized by John Coltrane. Perhaps it is not so surprising that this century's own narrative art is the cinema.

In Padua there is a chapel that was built in the year 1300 on the site of a Roman arena. The chapel adjoined a palace that has now disappeared without a trace, as palaces often do. When the chapel was finished, Giotto and his assistants began painting frescoes all over the interior walls and ceiling. These have survived. They tell the story of the life of Christ and the Last Judgement. They show heaven, earth and hell. When you are inside the chapel, you are surrounded by the

events depicted. The story-line is very strong. The scenes are dramatic. (The one where Judas kisses Christ, for example, offers an unforgettable rendering of treachery.) Everywhere the expressions and gestures are charged with intense meaning—like those in silent films. Giotto was a realist and a great *metteur en scène*. The scenes, which follow one after another, are full of stark material details, taken from life. This chapel, built and conceived seven hundred years ago, is, I think, more like a cinema than anything else that has come down to us from before the twentieth century. Somebody one day should name a cinema the Scrovegni—which is how the chapel is called, after the family who had the palace built.

Nevertheless, there is a very obvious difference between cinema and painting. The cinema image moves and the painted image is static. And this difference changes our relationship to the *place* where we are looking at the images. In the Scrovegni you have the feeling that everything which has happened in history has been brought there and belongs to an eternal present in the chapel in Padua. The frescoes—even those that have clearly deteriorated—inspire a sense of transcendental permanence.

The painted image makes what is absent—in that it happened far away or long ago—present. The painted image delivers what it depicts to the here and now. It collects the world and brings it home. A seascape by Turner may appear to contradict what I've just said. But even before a Turner the spectator remains aware of the pigment that has been scraped on to the canvas—and indeed this awareness is part of his excitement. Turner comes out of the gale with a painting. Turner crosses the Alps and brings *back* an image of nature's awesomeness. Infinity and the surface of the canvas play hide-and-seek in a room where a painting is hung. This

is what I meant when I said painting collects the world and brings it home. And it can do this because its images are static and changeless.

IMAGINE A CINEMA SCREEN being installed in the Scrovegni Chapel and a film being projected on to it. Let's say the scene where the angel appears to the shepherds to announce Christ's birth at Bethlehem. (The legend has it that Giotto, when he was a boy, was a shepherd.) Watching this film, we would be transported *out* of the chapel to a field somewhere at night, where shepherds are lying in the grass. The cinema, because its images are moving, takes us *away* from where we are to the *scene of action*. (Action! murmurs or shouts the director to set the scene in motion.) Painting brings home. The cinema transports elsewhere.

Compare now the cinema with theatre. Both are dramatic arts. Theatre brings actors before a public and every night during the season they re-enact the same drama. Deep in the nature of theatre is a sense of ritual return.

The cinema, by contrast, transports its audience individually, singly, *out* of the theatre towards the unknown. Twenty takes of the same scene may be shot, but the one that is used will be selected because it has the most convincing look and sound of a First Time.

Where, then, do these First Times take place? Not, of course, on the set. *On* the screen? The screen, as soon as the lights go out, is no longer a surface but a space. Not a wall, as the walls of the Scrovegni Chapel, but more like a sky. A sky filled with events and people. From where else would film stars come if not from a film sky?

The scale and grain of the cinema screen enhance the

sky effect. This is why cinema films shown on small TV screens lose so much of their sense of destiny. The meetings are no longer in a sky but in a kind of cupboard.

At the end of a play, the actors, abandoning the characters they have been playing, come to the footlights to take their bow. The applause they receive is a sign of recognition for their having brought the drama into the theatre tonight. At the end of a film, those protagonists who are still alive have to move on. We have been following them, stalking them, and, finally, out there, they have to elude us. Cinema is perpetually about leaving.

"If there is an aesthetics of the cinema," said René Clair, "it can be summarised in one word: movement." One word: movies.

Maybe this is why so many couples, when they go to the cinema, hold hands, as they don't in the theatre. A response to the dark, people say. Perhaps a response to the travelling too. Cinema seats are like those in a jet plane.

When we read a story, we inhabit it. The covers of a book are like a roof and four walls. What is to happen next will take place within the four walls of the story. And this is possible because the story's voice makes everything its own. *Film is too close to the real* to be able to do this. And so it has no home ground. It is always coming and going. In a story which is read, suspense simply involves waiting. In a film it involves displacement.

To show that it is in the very nature of film to shuttle us between a here and a there, let us think of Bresson's first masterpiece—*Un Condamné à Mort s'Est Echappé*. Watching it, we scarcely ever leave the prisoner, Fontaine, who is either in his cell or in the exercise yard. Meticulously, step by step, we follow him preparing for his escape. The story is told in a very linear way, like one of the ropes Fontaine is making to escape with. It must be one of the most unilinear films

ever made. Yet all the while, on the soundtrack we hear the guards in the prison corridors and on the staircases, and, beyond, the sound of trains passing. (How much the cinema was in love with locomotives!) We remain *here* with Fontaine in his cell; but our imagination is being pulled to *there*, where the guards are doing their rounds, or to *there*, where men at liberty can still take trains. Continually, we are made aware of an elsewhere. This is part of the inevitable method of film narration.

The only way around it would be to shoot a whole story in one take and with a camera that didn't move. And the result would be a photocopy of theatre—without the all-important presence of the actors. Movies, not because we see things moving, but because a film is a shuttle service between different places and times.

IN EARLY WESTERNS there are those classic chase scenes in which we see a train and men on horses galloping beside it. Sometimes a rider succeeds in leaving his horse and pulling himself aboard the train. This action, so beloved by directors, is the emblematic action of cinema. All film stories use crossovers. Usually they occur not on the screen as an event but as the consequence of editing. And it is through these crossovers that we are made to feel the destiny of the lives we are watching.

When we read, it is the story's voice which conveys a sense of destiny. Films are much nearer to the accidents of life, and in them destiny is revealed in the split second of a cut or the few seconds of a dissolve. These cuts, of course, are not accidental: we know that they are *intended* by the film—they reveal how the film is hand in glove with the destiny working in the story. The rest of the time this destiny is lurking elsewhere, in the sky behind.

It may seem that, eighty years after Griffith and Eisenstein, I'm simply saying that the secret of the Seventh Art is editing! My argument, however, concerns not the making of films, but how they work, when made, on the spectator's imagination.

Walt Whitman, who was born at the end of the Napoleonic age and died two years before the first reels were shot, foresaw our cinematographic vision. His intensely democratic sense of human destiny made him the poet of the cinema before the cameras were made. Listen:

> The little one sleeps in its cradle,
> I lift the gauze and look a long time, and silently
> brush away flies with my hand.
>
> The youngster and the red-faced girl turn aside up
> the bushy hill,
> I peeringly view them from the top.
>
> The suicide sprawls on the bloody floor of the
> bedroom,
> I witness the corpse with its dabbled hair, I note
> where the pistol has fallen.
>
> (*Song of Myself,* section 8)

FILM NARRATION has another unique quality. The French critic Lucien Sève once said that a film shot offers scarcely more explanations than reality itself, and from this arises its enigmatic power to "cling to the surface of things." André Bazin wrote, "Cinema is committed to communicate only by way of what is real." Even as we wait to be transported elsewhere, we are held fascinated by the *presence* of what has come towards us out of the sky. The most familiar sights— a child sleeping, a man climbing a staircase—become mys-

terious when filmed. The mystery derives from our closeness to the event and from the fact that the filmed event still retains a multiplicity of possible meanings. What we are being shown has, at one and the same time, something of the focus, the intentionality, of art, and the unpredictability of reality. Directors like Satyajit Ray, Rossellini, Bresson, Buñuel, Forman, Scorsese, and Spike Lee have used non-professional actors precisely in order that the people we see on the screen may be scarcely more *explained* than reality itself. Professionals, except for the greatest, usually play not just the necessary role, but an explanation of the role.

Films which are null and void are so not because of their trivial stories but because there is nothing else but story. All the events they show have been tailor-made for the story and have no recalcitrant body to them. There are no real surfaces to cling to.

Paradoxically, the more familiar the event, the more it can surprise us. The surprise is that of rediscovering the world (a child asleep, a man, a staircase) after an absence elsewhere. The absence may have been very brief, but in the sky we lose our sense of time. Nobody has used this surprise in his films more crucially than Tarkovsky. With him we come back to the world with the love and caring of ghosts who left it.

No other narrative art can get as close as the cinema to the variety, the texture, the skin of daily life. But its unfolding, its coming into being, its marriage with the Elsewhere, reminds us of a longing, or a prayer.

Fellini asks:

What is an artist? A provincial who finds himself somewhere between a physical reality and a metaphysical one. Before this metaphysical reality we are all of us provincial. Who are the true citizens of

transcendence? The Saints. But it's this in-between that I'm calling a province, this frontier-country between the tangible world and the intangible one—which is really the realm of the artist.

Ingmar Bergman says:

> Film as dream, film as music. No art passes our conscience in the way film does, and goes directly to our feelings, deep down into the dark rooms of the soul.

From the beginning the cinema's talent for inventing dreams was seized upon. This faculty of the medium is why cinema industries have often become *dream factories*, in the most pejorative sense of the term, producing soporifics.

Yet there is no film that does not partake of dream. And the great films are dreams which reveal. No two moments of revelation are the same. *The Gold Rush* is very different from *Pather Panchali*. Nevertheless, I want to ask the question: What is the longing that film expresses and, at its best, satisfies? Or, what is the nature of this filmic revelation?

Film stories, as we have seen, inevitably place us in an Elsewhere, where we cannot be at home. Once again the contrast with television is revealing. TV focusses on its audience being at home. Its serials and soap operas are all based on the idea of *a home from home*. In the cinema, by contrast, we are travellers. The protagonists are strangers to us. It may be hard to believe this, since we often see these strangers at their most intimate moments, and since we may be profoundly moved by their story. Yet no individual character in a film do we *know*—as we know, say, Julien Sorel, or Macbeth, Na-

19

tasha Rostova, or Tristram Shandy. We cannot get to know them, for the cinema's narrative method means that we can only encounter them, not live with them. We meet in a sky where nobody can stay. How then does the cinema overcome this limitation to attain its special power? It does so by celebrating what we have in common, what we share. The cinema longs to go beyond individuality. Think of Citizen Kane, an arch individualist. At the beginning of the story he dies, and the film tries to put together the puzzle of who he really was. It turns out that he was multiple. If we are eventually moved by him, it is because the film reveals that somewhere Kane might have been a man like any other. As the film develops, it dissolves his individuality. Citizen Kane becomes a co-citizen with us.

The same is not true of the Master Builder in Ibsen's play or Prince Myshkin in Dostoevsky's novel *The Idiot*. In *Death in Venice* Thomas Mann's Aschenbach dies discreetly, privately; Visconti's Aschenbach dies publicly and theatrically, and the difference is not merely the result of Visconti's choices but of the medium's narrative need. In the written version we *follow* Aschenbach, who retires like an animal to die in hiding. In the film version Bogarde comes towards us and dies in close-up. In his death he approaches us.

When reading a novel, we often identify ourselves with a given character. In poetry we identify ourselves with the language itself. Cinema works in yet another way. Its alchemy is such that the characters come to identify themselves with us! The only art in which this can happen.

Take the old-age pensioner, Umberto D., in De Sica's masterpiece. He has been made anonymous by age, indifference, poverty, homelessness. He has nothing to live for and he wants to kill himself. At the end of the story, only the thought of what will happen to his dog prevents him from

doing so. But by now this nameless man has, for us, come to represent life. Consequently, his dog becomes an obscure hope for the world. As the film unfolds, Umberto D. begins to *abide* in us. The biblical term defines with surprising precision how De Sica's film—and any successful narrative film—has to work. Heroes and heroines, defeated or triumphant, come out of the sky to abide in us. At this moment Elsewhere becomes everywhere.

Umberto D. comes to abide in us because the film reminds us of all the reality that we potentially share with him, and because it discards the reality which distinguishes him from us, which has made him separate and alone. The film shows what happened to the old man in life and, in the showing, opposes it. This is why film—when it achieves art—becomes like a human prayer. Simultaneously a plea and an attempt to redeem.

The star system too, in a paradoxical way, is dependent upon sharing. We know very well that a star is not just the actress or actor. The latter merely serve the star—often tragically. The star always has a different and mythic name. The star is a figure accepted by the public as an archetype. This is why the public enjoy and recognize a star playing, relatively undisguised, many different roles in different films. The overlapping is an advantage, not a hindrance. Each time, the star pulls the role, pulls the character in the film story, towards her or his archetype.

The difficulty of labelling the archetypes should not encourage us to underestimate their importance.

Take Laurel and Hardy. They form a couple. Because they do so, women are marginal in the stories of their films. Laurel quite often dresses up as a woman. Both of them—in their sublime comic moments—have certain habitual gestures which are distinctly "effeminate." So why is it that they do not register in the public imagination as homosexual? It is

because, archetypally, Laurel and Hardy are kids—somewhere between the ages of seven and eleven. The public imagination perceives them as kid wreckers of an adult world order. And therefore, given their archetype age, they are not yet sexual beings! It is thanks to their archetype that they are not sexually labelled.

FINALLY, let's return to the fact that film pulls us into the visible world: the one into which we are thrown at birth and which we all share. Painting does not do this; it interrogates the visible. Nor does still photography—for all still photographs are about the past. Only movies pull us into the present and the visible, the visible which surrounds us all.

Film doesn't have to say "tree": it can show a tree. It doesn't have to describe a crowd: it can be in one. It doesn't have to find an adjective for mud; it can be up to the wheels in it. It doesn't have to analyse a face, it can approach one. It doesn't have to lament, it can show tears.

Here is Whitman, prophetically imagining the screen image as it addresses the public:

> Translucent mould of me it shall be you!
> Shaded ledges and rests it shall be you!
> Firm masculine colter it shall be you!
> Whatever goes to the tilth of me it shall be you!
> You my rich blood! your milky stream pale strippings
> of my life!
> Breast that presses against other breasts it shall be
> you!
> My brain it shall be your occult convolutions!
> Root of wash'd sweet-flag! timorous pond-snipe! nest
> of guarded duplicate eggs! it shall be you!

ev'ry time we say goodbye

Mix'd tussled hay of head, beard, brawn, it shall be
 you!
Trickling sap of maple, fibre of manly wheat, it shall
 be you!
Sun so generous it shall be you!
Vapors lighting and shading my face it shall be you!

(*Song of Myself*, section 24)

MOST FILMS, of course, do not achieve universality. Nor can the universal be consciously pursued—for such an ambition leads only to pretension or rhetoric. I have been trying to understand the modality of how cinema occasionally bestows universality upon a film-maker's work. Usually it is in response to love or compassion. At such moments cinema does something very complicated in a simpler way than any other art can. Here are two examples.

In Jean Vigo's *L'Atalante* a sailor marries a peasant girl. We see the couple come out of church at the end of a joyless, almost sinister, ceremony, with all the men dressed in black, intimidated by the priest, and with old women whispering scandal. Then the sailor takes his wife home to his barge on a river. She is swung aboard on a yardarm by the crew, who consist of a kid and an old man. The *Atalante* casts off and sails away on its long journey to Paris. Perhaps it is dusk. The bride, still in white, slowly walks along the length of the barge towards the prow. Alone, she is being borne away and she walks solemnly, as if to another altar that is no longer a sinister one. On the bank a woman with a child sees her passing down the river, and she crosses herself as if she has just seen a vision. And she has. She has seen at that moment a vision of every bride in the world.

In the *Mean Streets* of Martin Scorsese, a gang of neigh-

23

bourhood friends put up daily, makeshift shelters against the flames. They do this separately and together. The flames are those of hell. The shelters are: wisecracks, shoot-outs, whiskeys, memories of innocence, a windfall of a hundred bucks, a new shirt. New York Italian Catholics, they know about Jesus, but here, on the Lower East Side, there is no redemption; everyone is on the back of everyone, trying not to sink down into the pit. Charlie is the only one capable of bullshit pity, though he can save nobody. Driving away from yet another fight, he says out loud: "I know things haven't gone well tonight, Lord, but I'm trying." And, in that instant, which is buried in the shit of Manhattan, he becomes the repentant child in all of us and a soul in Dante's Hell—Dante, whose vision of the Inferno was modelled after the cities he knew in his time.

What is saved in the cinema when it achieves art is a spontaneous continuity with all of mankind. It is not an art of the princes or of the bourgeoisie. It is popular and vagrant. In the sky of the cinema people learn what they might have been and discover what belongs to them apart from their single lives. Its essential subject—in our century of disappearances—is the soul, to which it offers a global refuge. This, I believe, is the key to its longing and its appeal.

THAT WHICH IS HELD

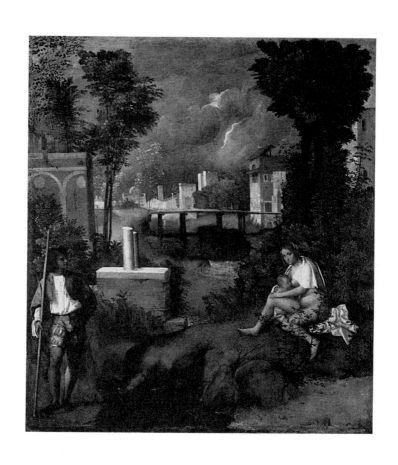

DETAIL FROM GIORGIONE'S PAINTING *LA TEMPESTA*.

26

I AM THINKING in front of Giorgione's *Tempest* and I want to begin with a quotation from Osip Mandelstam: "For Dante time is the content of history felt as a single synchronic act. And inversely the purpose of history is to keep time together⟩ so that all are brothers and companions in the same quest⟩ and conquest of time."

Of all that we have inherited from the nineteenth century, only certain axioms about time have passed largely unquestioned. The left and right, evolutionists, physicists, and most revolutionaries, all accept—at least on a historical scale—the nineteenth-century view of a unilinear and uniform "flow" of time.

Yet the notion of a uniform time within which *all* events can be temporally related depends upon the synthesizing capacity of a mind. Galaxies and particles in themselves propose nothing. We face at the start a phenomenological problem. We are obliged to begin with a conscious experience.

Everybody has noticed that, despite clocks and the regular turning of the earth, time is experienced as passing at different rates. This "impression" is generally dismissed as subjective, because time, according to the nineteenth-century view, is objective, incontestable and indifferent; to its indifference there are no limits.

Yet perhaps our experience should not be dismissed so quickly. Supposing we accept the clocks: time does not slow

27

down or accelerate. But time appears to pass at different rates because our experience of its passing involves not a single but *two* dynamic processes which are opposed to each other: as accumulation and dissipation.

The deeper the experience of a moment, the greater the accumulation of experience. This is why the moment is lived as longer. The dissipation of the time-flow is checked. The lived *durée* is not a question of length but of depth or density. Proust is the master who gave this truth a literary form.

Yet it is not only a cultural truth. A natural equivalent of the periodic increase of the density of lived time may be found in those days of alternating sun and rain, in the spring or early summer, when plants grow, almost visibly, several millimetres or centimetres a day. These hours of spectacular growth and accumulation are *incommensurate* with the winter hours when the seed lies inert in the earth.

The content of time, which is to say that which time carries, seems to entail another dimension. Whether one calls this dimension the fourth, the fifth, or even (in relation to time) the third is unimportant, and only depends upon the space-time model that one is using. What matters and is important is that this dimension is intractable to the regular, uniform flow of time. There may be a sense in which time does not sweep *all* before it; to assert that it did was a specifically nineteenth-century article of faith.

Earlier this intractable dimension was allowed for. It is present in all cyclic views of time. According to such views, time passes, time goes on, and it does so by turning on itself like a wheel. Yet for a wheel to turn, there needs to be a surface like the ground which resists, which offers friction. It is against this resistance that the wheel turns. Cyclic views of time are based on a model whereby two forces are in play: a force (time) moving in one direction and a force resisting that movement.

Today the intractable dimension lives a ghostly life within the cyclic measurements—seconds, minutes, days, years—which we still use to measure time. The term light-year is eloquent of this persistent ghost. To measure astronomic distances one takes as a unit that distance which light travels in a year. The magnitude of such distances, the degree of *separation* they imply, seems boundless. Yet hidden within the conceptual system for measuring such boundlessness is the indispensable, local, cyclic unit of the year, a unit which is recognized by its *returning*.

The body ages. The body is preparing to die. No theory of time offers a reprieve here. Yet we condemn ourselves as no other culture has done.

The spectre of death has always haunted man. Death and Time were always in alliance. Time took away more or less slowly, and Death more or less suddenly.

Yet Death was also thought of as the companion of life, as the pre-condition for that which came into Being from Non-being: one was not possible without the other. As a result, Death was qualified by that which it could not destroy, or by that which would return.

That life is brief was continually lamented. Time was Death's agent, and one of life's constituents. But the timeless—that which Death could not destroy—was another. All cyclic views of time held these two constituents together: the wheel turning and the ground on which it turned.

Modern thought has removed time from this unity and transformed it into a single, all-powerful and active force. Modern thought has transferred the spectral character of Death to the notion of time itself. Time has become Death triumphant over all.

The concept of entropy is the figure of Death translated into scientific principle. Yet, whereas Death used to be thought of as being the condition of life, entropy, it is main-

tained, will eventually exhaust and extinguish not only lives but life itself. And entropy, as Eddington termed it, "is time's arrow." Here is the finality of modern despair, against which no plea is possible. Our totalitarianism begins with our teleology.

The modern transformation of time from a condition into a force began with Hegel. For Hegel, however, the force of history was positive; there has rarely been a more optimistic philosopher. Later Marx set out to prove that this force—the force of history—was subject to man's actions and choices. The always-present drama in Marx's thinking, the original opposition of his dialectics, stems from the fact that he both accepted the modern transformation of time into the supreme force *and* wished to return this supremacy into the hands of man. This is why his thought was—in every sense of the word—gigantic. The size of man—his potential, his coming power—would replace the timeless.

Today, as the culture of capitalism abandons its claim to be a culture and becomes nothing more than an instant practice, the force of time, still retaining its absolute supremacy, is felt to be inhuman and annihilating. The planet of the earth and the universe are running down. Disorder increases with every time-unit that passes. The envisaged final state of maximum entropy, where there will be no activity at all, is termed heat death.

To question the finality of the principle of entropy is not to dispute the second law of thermodynamics. Within a given system this and the other laws of thermodynamics can apply to what unfolds within time. They are laws of time's processes. It is their finality which needs to be disputed.

The process of increasing entropy ends with heat death. It began with a state of total order (perfection?), which in astrophysical terms is thought of as an explosion. The theory necessitates a beginning and an end; both these face on to

what is beyond time. The theory of entropy ultimately treats time as a parenthesis, and yet has nothing to say, and has eliminated everything that might be said, about what precedes or follows the parenthesis. Therein lies its innocence.

Many previous cosmological explanations of the world proposed, as does the theory of entropy, an ideal original state and afterwards, for man, a continually deteriorating situation. The Golden Age, the Garden of Eden, the Time of the Gods— all were far away from the misery of the present.

That life may be seen as a fall is intrinsic to the human faculty of imagination. To imagine is to conceive of that height from which the Fall takes place.

In most earlier cosmogonies, however, time was cyclic and this meant that the "ideal" original state would one day return or was *retrievable*. Not usually in a lifetime—this was only the occasional revolutionary hope—but in the lifetime of existence. Recognition of the Fall coexisted with hope. Accumulation and dissipation increased concurrently. With entropy and the nineteenth-century view of time, we face only the irretrievable and only dissipation.

The facing of this may be considered an act of intellectual courage. Yet it is also an act of inhibition.

The sexual thrust to reproduce and to fill the future is a thrust against the current of time flowing towards the past. The genetic information which assures reproduction works against dissipation. The sexual animal—like a grain of corn— is a conduit of the past into the future. The scale of that span over millennia and the distance covered by that temporal short circuit which is fertilization are such that sexuality opposes the impersonal passing of time and is antithetical to it.

Every life is both created by and *held* in the encounter of these two opposing forces. The paired relationship of Eros and Thanatos is an expression of this holding. To speak of

31

such a "holding" is another way of defining Being. What is so baffling and mysterious about the state of Being is that it represents both stillness and movement. The stillness of an equilibrium created by the movement of two opposing forces. The nineteenth-century inhibition was not towards the function of sexuality in nature; it was towards the intimacy of the relation between sexuality and love. The two had to be kept as far apart as possible. Partly because in capitalist practice—and capitalism was now annexing the entire world—all love had to be reduced to the narrowly private; and partly because the century's view of time left no place (except in poetry) for the energy of love. It was Blake who saw this so clearly and so early.

Love, in the history of human development, was born, and still is, from sexuality. Without the initial force of the sexual impulse *across, towards* another body, the transmigration of the self which constitutes love would never have been possible. The distinction between love, in any of its sexual forms, and simple sexuality, can be seen in their different relations to time.

Sexuality is a source of continual renewal—renewal of the species and renewal of itself. The sexual is forever unfinished, is never complete. It finishes only to rebegin, *as if for the first time.*

By contrast, the utopia of love is completion to the point of stillness. The ideal act of love is to contain all. The love poetry of every continent and century testifies to this. "Here I understand," wrote Camus, "what they call glory: the right to love without limits." But this ideal act is not a passive one, for the totality which love has to continually reclaim is precisely the totality which time so convincingly appears to fragment and hide. Love is a reconstitution—in the heart as much as in the mind—of that "holding," of that Being, which occurs in the momentary equilibrium created by the opposing forces of sexuality and time.

Sublimated forms of love—political, social, religious, cultural—reclaim a totality on a historical as well as a personal scale. But in every form of love a past and a future are grasped as if present. The momentary "holding," seized by the imagination through the energy of love, realizes a whole, which is outside time.

Such realizations are intrinsic to the human experience and occur, more or less intensely, all the while. To ask whether love has or has not an objective existence is to ask a somewhat mechanical question, for it ignores that what we feel can be a response to what *approaches* us from our surroundings; surroundings in both time and space. Heidegger suggests the nature of this approach: "It might be that that which distinguishes man as man, is determined precisely by what we must think about here: man, who is concerned with, approached by presence, who, through being thus approached, is himself present in his own way for all present and absent things."

This "approaching" has always been recognized by artists and in the modern era has been termed inspiration.

Much has to be thought through. Particularly the question of how each art finds its own specific means for giving form to a whole, realized by love. Poetry would seem to be the simplest art to approach in this sense because it so often speaks of love, sexual or otherwise. Yet for this very reason poetry could confuse the inquiry.

For it is not a question of saying that every painter (Goya?) has loved what he has painted, that every story-teller (Stendhal?) has loved all his characters, that all music is lyrical. Rather it is a question of seeing that the artist's will to preserve and complete, to create an equilibrium, to hold—and in that "holding" to hope for an ultimate assurance—that this derives from a lived or imagined experience of love.

This may seem close to Freud's theory of sublimation. Except for the important difference that Freud, given his

nineteenth-century view of time, could not distinguish be-
tween sexuality and love in terms of what is intractable to
time. I am arguing that sexuality is the antithesis of art, but
that love is the human model for both.

Does this mean that historical analysis is therefore ir-
relevant? No. The means used by each art at different periods
for giving form to "what is held" are often historically deter-
mined. To analyse these determinants helps us to understand
better the conditions under which people were living or were
trying to live, and this is to understand better the form of
their hopes.

What is *ahistorical* is the need to hope. And the act of
hoping is inseparable from the energy of love, from that which
"holds," from that which is art's constant example.

There is a question which finally has to be answered,
one way or the other. Is art consolation or revelation? Modern
aesthetics have mostly avoided this question by reducing art
to the personal and private; most superficially by reducing it
to a question of taste; more subtly, by isolating the artistic
experience by refusing to place what poetry says *beside* the
findings of science—for example, what poetry says, often
explicitly, about that which is intractable to time. "More
permanent than anything on earth is sadness," wrote Akh-
matova, "and more long-lived is the regal word."

Art is either a social practice to maintain illusions (a
conclusion not so different from that of many Althusserians),
or it is a glimpse of what lies beyond other practices, beyond
them because it is not subject to the tyranny of the modern
view of time.

I began with a quotation from Mandelstam. The sentence
which follows reads: "Dante is anti-modernist. His topicality
is inexhaustible, incalculable, perennial."

There is no question of looking away from the modern
world and its practices. There is no question of a Pre-

34

Raphaelite flight back to the Middle Ages. It is rather that Dante advances towards us. And in the specific purgatory of the modern world, created and maintained by corporate capitalism, every injustice is grounded in that modern unilinear view of time, for which the only relation conceivable is that between cause and effect. In contrast to this, in defiance of this, the "single synchronic act" is that of loving.

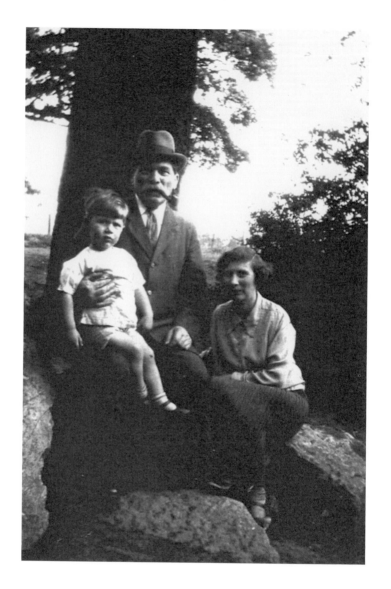

PHOTO OF AUTHOR WITH MOTHER AND GRANDFATHER.

A
LOAD OF SHIT

IN ONE OF HIS BOOKS, Milan Kundera dismisses the idea of God because, according to him, no God would have designed a life in which shitting was necessary. The way Kundera asserts this makes one believe it's more than a joke. He is expressing a deep affront. And such an affront is typically elitist. It transforms a natural repugnance into a moral shock. Elites have a habit of doing this. Courage, for instance, is a quality that all admire. But only elites condemn cowardice as vile. The dispossessed know very well that under certain circumstances everyone is capable of being a coward.

A week ago I cleared out and buried the year's shit. The shit of my family and of friends who visit us. It has to be done once a year and May is the moment. Earlier it risks to be frozen and later the flies come. There are a lot of flies in the summer because of the cattle. A man, telling me about his solitude not long ago said, "Last winter I got to the point of missing the flies."

First I dig a hole in the earth—about the size of a grave but not so deep. The edges need to be well cut so the barrow doesn't slip when I tip it to unload. Whilst I'm standing in the hole, Mick, the neighbour's dog, comes by. I've known him since he was a pup, but he has never before seen me there before him, less tall than a dwarf. His sense of scale is disturbed and he begins to bark.

However calmly I start the operation of removing the shit from the outhouse, transporting it in the barrow, and emptying it into the hole, there always comes a moment when I feel a kind of anger rising in me. Against what or whom? This anger, I think, is atavistic. In all languages "Shit!" is a swear word of exasperation. It is something one wants to be rid of. Cats cover their own by scraping earth over it with one of their paws. Men swear by theirs. Naming the stuff I'm shovelling finally provokes an irrational anger. Shit!

COW DUNG and horse dung, as muck goes, are relatively agreeable. You can even become nostaligic about them. They smell of fermented grain, and on the far side of their smell there is hay and grass. Chicken shit is disagreeable and rasps the throat because of the quantity of ammonia. When you are cleaning out the hen house, you're glad to go to the door and take a deep breath of fresh air. Pig and human excrement, however, smell the worst, because men and pigs are carnivorous and their appetites are indiscriminate. The smell includes the sickeningly sweet one of decay. And on the far side of it there is death.

Whilst shovelling, images of Paradise come into my mind. Not the angels and heavenly trumpets, but the walled garden, the fountain of pure water, the fresh colours of flowers, the spotless white cloth spread on the grass, ambrosia. The dream of purity and freshness was born from the omnipresence of muck and dust. This polarity is surely one of the deepest in the human imagination, intimately connected with the idea of home as a shelter—shelter against many things, including dirt.

In the world of modern hygiene, purity has become a

purely metaphoric or moralistic term. It has lost all sensuous reality. By contrast, in poor homes in Turkey the first act of hospitality is the offer of lemon eau-de-Cologne to apply to the visitors' hands, arms, neck, face. Which reminds me of a Turkish proverb about elitists: "He thinks he is a sprig of parsley in the shit of the world."

The shit slides out of the barrow when it's upturned with a slurping dead weight. And the foul sweet stench goads, nags teleologically. The smell of decay, and from this the smell of putrefaction, of corruption. The smell of mortality for sure. But it has nothing to do—as puritanism with its loathing for the body has consistently taught—with shame or sin or evil. Its colours are burnished gold, dark brown, black: the colours of Rembrandt's painting of Alexander the Great in his helmet.

A STORY from the village school that Yves my son tells me:

It's autumn in the orchard. A rosy apple falls to the grass near a cow pat. Friendly and polite, the cow shit says to the apple: "Good morning, Madame la Pomme, how are you feeling?"

She ignores the remark, for she considers such a conversation beneath her dignity.

"It's fine weather, don't you think, Madame la Pomme?"

Silence.

"You'll find the grass here very sweet, Madame la Pomme."

Again, silence.

At this moment a man walks through the orchard, sees the rosy apple, and stoops to pick it up. As he bites into the

apple, the cow shit, still irrepressible, says: "See you in a little while, Madame la Pomme!"

What makes shit such a universal joke is that it's an unmistakable reminder of our duality, of our soiled nature and of our will to glory. It is the ultimate *lèse-majesté*.

As I EMPTY the third barrow of shit, a chaffinch is singing in one of the plum trees. Nobody knows exactly why birds sing as much as they do. What is certain is that they don't sing to deceive themselves or others. They sing to announce themselves as they are. Compared to the transparency of birdsong, our talk is opaque because we are obliged to search for the truth instead of being it.

I think of the people whose shit I'm transporting. So many different people. Shit is what is left behind undifferentiated: the waste from energy received and burnt up. This energy has myriad forms, but for us humans, with our human shit, all energy is partly verbal. I'm talking to myself as I lift the shovel, prudently, so that too much doesn't fall off on to the floor. Evil begins not with decomposing matter but with the human capacity *to talk oneself into*.

The eighteenth-century picture of the noble savage was short-sighted. It confused a distant ancestor with the animals he hunted. All animals live with the law of their species. They know no pity (though they know bereavement) but they are never perverse. This is why hunters dreamt of certain animals as being naturally noble—of having a spiritual grace which matched their physical grace. It was never the case with man.

Nothing in the nature around us is evil. This needs to be repeated since one of the human ways of *talking oneself into* inhuman acts is to cite the supposed cruelty of nature.

The just-hatched cuckoo, still blind and featherless, has a special hollow like a dimple on its back, so that it can hump out of the nest, one by one, its companion fledglings. Cruelty is the result of *talking oneself into* the infliction of pain or into the conscious ignoring of pain already inflicted. The cuckoo doesn't talk itself into anything. Nor does the wolf.

The story of the Temptation with the other apple (not Madame la Pomme) is well told. ". . . the serpent said unto the woman, Ye shall surely not die." She hasn't eaten yet. Yet these words of the serpent are either the first lie or the first play with empty words. (Shit! Half a shovelful has fallen off.) Evil's mask of innocence.

"A certain phraseology is obligatory," said George Orwell, "if one wants to name things without calling up mental images of them."

PERHAPS THE INSOUCIANCE with which cows shit is part of their peacefulness, part of the patience which allows them to be thought of in many cultures as sacred.

Evil hates everything that has been physically created. The first act of this hatred is to separate the order of words from the order of what they denote. O Hansard!

Mick the dog follows me as I trundle the barrow to the hole. "No more sheep!" I tell him. Last spring, palled up with another dog, he killed three. His tail goes down. After killing he was chained up for three months. The tone of my half-joking voice, the word "sheep," and the memory of the chain make him cringe a little. But in his head he doesn't call spilt blood something else, and he stares into my eyes.

NOT FAR from where I dug the hole, a lilac tree is coming into flower. The wind must have changed to the south, for this time I can smell the lilac through the shit. It smells of mint mixed with a lot of honey.

This perfume takes me back to my very early childhood, to the first garden I ever knew, and suddenly from that time long ago I remember both smells, from long before either lilac or shit had a name.

MOTHER

(For Katya)

43

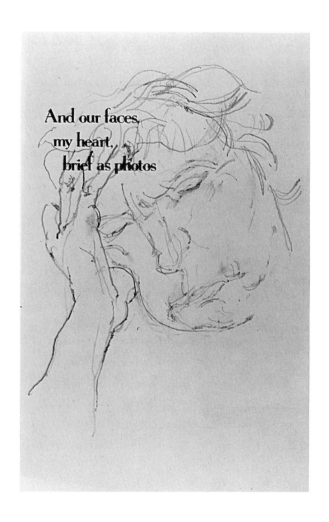

And our faces,
my heart,
brief as photos

DRAWINGS BY AUTHOR OF HIS MOTHER.

44

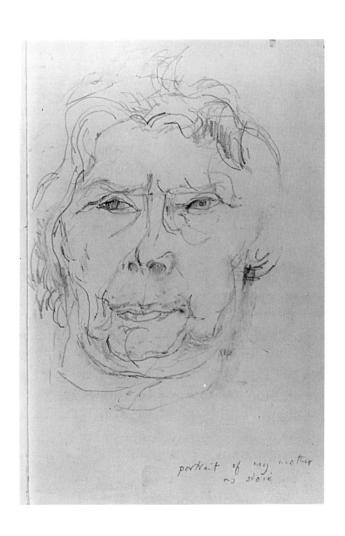

portrait of my mother
as stoic

45

FROM THE AGE of five or six I was worried about the death of my parents. The inevitability of death was one of the first things I learnt about the world on my own. Nobody else spoke of it, yet the signs were so clear.

Every time I went to bed—and in this I am sure I was like millions of other children—the fear that one or both of my parents might die in the night touched the nape of my neck with its finger. Such a fear has, I believe, little to do with a particular psychological climate and a great deal to do with nightfall. Yet since it was impossible to say "You won't die in the night, will you?" (when Grandmother died, I was told she had gone to have a rest, or—this was from my uncle who was more outspoken—that she had passed over), since I couldn't ask the real question and I sought a reassurance, I invented—like millions before me—the euphemism See you in the morning! To which either my father or mother who had come to turn out the light in my bedroom would reply, See you in the morning, John.

After their footsteps had died away, I would try for as long as possible not to lift my head from the pillow so that the last words spoken remained, trapped like fish in a rockpool at low tide, between my pillow and my ear. The implicit promise of the words was also a protection against the dark. The words promised that I would not (yet) be alone.

Now I'm no longer usually frightened by the dark and

my father died ten years ago and my mother a month ago at
the age of ninety-three. It would be a natural moment to write
an autobiography. My version of my life can no longer hurt
either of them. And the book, when finished, would be there,
a little like a parent. Autobiography begins with a sense of
being alone. It is an orphan form. Yet I have no wish to do
so. All that interests me about my past life are the common
moments. The moments—which if I relate them well
enough—will join countless others lived by people I do not
personally know.

Six weeks ago my mother asked me to come and see her;
it would be the last time, she said. A few days later, on the
morning of my birthday, she believed she was dying. Open
the curtains, she said to my brother, so I can see the trees.
In fact, she died the following week.

On my birthdays as a child, it was my father rather than
she who gave me memorable presents. She was too thrifty.
Her moments of generosity were at the table, offering what
she had bought and prepared and cooked and served to
whoever came into the house. Otherwise she was thrifty. Nor
did she ever explain. She was secretive, she kept things to
herself. Not for her own pleasure, but because the world
would not forgive spontaneity, the world was mean. I must
make that clearer. She didn't believe life was mean—it was
generous—but she had learnt from her own childhood that
survival was hard. She was the opposite of quixotic—for she
was not born a knight and her father was a warehouse foreman
in Lambeth. She pursed her lips together, knitted her brows
as she calculated and thought things out and carried on with
an unspoken determination. She never asked favors of anyone.
Nothing shocked her. From whatever she saw, she just drew
the necessary conclusions so as to survive and to be dependent
on nobody. If I were Aesop, I would say that in her prudence
and persistence my mother resembled the agouti. (I once

wrote about an agouti in the London zoo but I did not then realize why the animal so touched me.) In my adult life, the only occasions on which we shouted at each other were when she estimated I was being quixotic.

When I was in my thirties, she told me for the first time that ever since I was born she had hoped I would be a writer. The writers she admired when young were Bernard Shaw, J. M. Barrie, Compton Mackenzie, Warwick Deeping, E. M. Dell. The only painter she really admired was Turner—perhaps because of her childhood on the banks of the Thames.

Most of my books she didn't read. Either because they dealt with subjects which were alien to her or because— under the protective influence of my father—she believed they might upset her. Why suffer surprise from something which, left unopened, gives you pleasure? My being a writer was unqualified for her by what I wrote. To be a writer was to be able to see to the horizon where, anyway, nothing is ever very distinct and all questions are open. Literature had little to do with the writer's vocation as she saw it. It was only a by-product. A writer was a person familiar with the secrets. Perhaps in the end she didn't read my books so that they should remain more secret.

If her hopes of my becoming a writer—and she said they began on the night after I was delivered—were eventually realized, it was not because there were many books in our house (there were few) but because there was so much that was unsaid, so much that I had to discover the existence of on my own at an early age: death, poverty, pain (in others), sexuality . . .

These things were there to be discovered within the house or from its windows—until I left for good, more or less pre-pared for the outside world, at the age of eight. My mother never spoke of these things. She didn't hide the fact that she

was aware of them. For her, however, they were wrapped secrets, to be lived with but never to be mentioned or opened. Superficially, this was a question of gentility, but profoundly, of a respect, a secret loyalty to the enigmatic. My rough-and-ready preparation for the world did not include a single explanation—it simply consisted of the principle that events carried more weight than the self.

Thus, she taught me very little—at least in the usual sense of the term: she a teacher about life, I a learner. By imitating her gestures I learnt how to roast meat in the oven, how to clean celery, how to cook rice, how to choose vegetables in a market. As a young woman she had been a vegetarian. Then she gave it up because she did not want to influence us children. Why were you a vegetarian? I once asked her, eating my Sunday roast, much later when I was first working as a journalist. Because I'm against killing. She would say no more. Either I understood or I didn't. There was nothing more to be said.

In time—and I understand this only now writing these pages—I chose to visit abattoirs in different cities of the world and to become something of an expert concerning the subject. The unspoken, the unfaceable beckoned me. I followed. Into the abattoirs and, differently, into many other places and situations.

The last, the largest and the most personally prepared wrapped secret was her own death. Of course I was not the only witness. Of those close to her, I was maybe the most removed, the most remote. But she knew, I think, with confidence that I would pursue the matter. She knew that if anybody can be at home with what is kept a secret, it was me, because I was her son who she hoped would become a writer.

The clinical history of her illness is a different story about which she herself was totally uncurious. Sufficient to say that

with the help of drugs she was not in pain, and that, thanks to my brother and sister-in-law who arranged everything for her, she was not subjected to all the mechanical ingenuity of aids for the artificial prolongation of life.

Of how many deaths—though never till now of my own mother's—have I written? Truly we writers are the secretaries of death.

She lay in bed, propped up by pillows, her head fallen forward, as if asleep.

I shut my eyes, she said, I like to shut my eyes and think. I don't sleep though. If I slept now, I wouldn't sleep at night.

What do you think about?

She screwed up her eyes which were gimlet sharp and looked at me, twinkling, as if I'd never, not even as a small child, asked such a stupid question.

Are you working hard? What are you writing?

A play, I answered.

The last time I went to the theatre I didn't understand a thing, she said. It's not my hearing that's bad though.

Perhaps the play was obscure, I suggested.

She opened her eyes again. The body has closed shop, she announced. Nothing, nothing at all from here down. She placed a hand on her neck. It's a good thing, make no mistake about it, John, it makes the waiting easier.

On her bedside table was a tin of hand cream. I started to massage her left hand.

Do you remember a photograph I once took of your hands? Working hands, you said.

No, I don't.

Would you like some more photos on your table? Katya, her granddaughter, asked her.

She smiled at Katya and shook her head, her voice very slightly broken by a laugh. It would be *so* difficult, so difficult, wouldn't it, to choose.

She turned towards me. What exactly are you doing?

I'm massaging your hand. It's meant to be pleasurable.

To tell you the truth, dear, it doesn't make much difference. What plane are you taking back?

I mumbled, took her other hand.

You are all worried, she said, especially when there are several of you. I'm not. Maureen asked me the other day whether I wanted to be cremated or buried. Doesn't make one iota of difference to me. How could it? She shut her eyes to think.

For the first time in her life and in mine, she could openly place the wrapped enigma between us. She didn't watch me watching it, for we had the habits of a lifetime. Openly, she knew that at that moment her faith in a secret was bound to be stronger than any faith of mine in facts. With her eyes still shut, she fingered the Arab necklace I'd attached round her neck with a charm against the evil eye. I'd given her the necklace a few hours before. Perhaps for the first time I had offered her a secret and now her hand kept looking for it.

She opened her eyes. What time is it?

Quarter to four.

It's not very interesting talking to me, you know. I don't have any ideas any more. I've had a good life. Why don't you take a walk?

Katya stayed with her.

When you are very old, she told Katya confidentially, there's one thing that's very, very difficult—it's very difficult to persuade other people that you're happy.

She let her head go back on to the pillow. As I came back in, she smiled.

In her right hand she held a crumpled paper handkerchief. With it she dabbed from time to time the corner of her mouth when she felt there was the slightest excess of spittle there. The gesture was reminiscent of one with which, many

years before, she used to wipe her mouth after drinking Earl Grey tea and eating watercress sandwiches. Meanwhile, with her left hand she fingered the necklace, cushioned on her forgotten bosom.

Love, my mother had the habit of saying, is the only thing that counts in this world. Real love, she would add, to avoid any factitious misunderstanding. But apart from that simple adjective, she never added anything more.

A STORY FOR AESOP

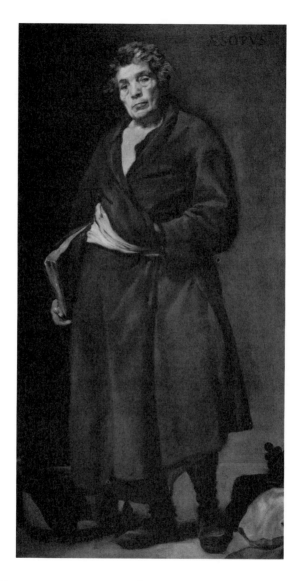

PORTRAIT OF AESOP BY VELÁZQUEZ.

THE IMAGE IMPRESSED ME when I set eyes upon it for the first time. It was as if it was already familiar, as if, as a child, I had already seen the same man framed in a doorway. The picture was painted by Velázquez around 1640. It is an imaginary, half–life-size portrait of Aesop.

He stands there, keeping a rendezvous. With whom? A bench of judges? A gang of bandits? A dying woman? Travellers asking for another story?

Where are we? Some say that the wooden bucket and the chammy leather indicate a tannery, and these same commentators remember Aesop's fable about the man who learnt gradually to ignore the stench of tanning hides. I'm not entirely convinced. Perhaps we are at an inn, amongst travellers on the road. His boots are as used as nags with sway backs. Yet at this moment he is surprisingly dust-free and clean. He has washed and douched his hair, which is still a little damp.

His itinerant pilgrim's robe has long since taken on the shape of his body, and his dress has exactly the same expression as his face. It has reacted as cloth to life, in the same way as his face has reacted as skin and bone. Robe and face appear to share the same experience.

His gaze now makes me hesitate. He is intimidating, he has a kind of arrogance. A pause for thought. No, he is not arrogant. But he does not suffer fools gladly.

Who was the painter's model for this historical portrait

of a man who lived two thousand years earlier? In my opinion it would be rash to assume that the model was a writer, or even a regular friend of Velázquez. Aesop is said to have been a freed slave—born perhaps in Sardinia. One might believe the same of the man standing before us. The power of his presence is of the kind which belongs exclusively to those without power. A convict in a Sicilian prison said to Danilo Dolci: "With all this experience reading the stars all over Italy, I've plumbed the depths of the universe. All of humanity under Christendom, the poor, the rich, princes, barons, counts, have revealed to me their hidden desires and secret practices."*

Legend has it that at the end of his life Aesop too was condemned for theft. Perhaps the model was an ex-convict, a one-time galley slave, whom Velázquez, like Don Quixote, met on the road. In any case he knows "their hidden desires and their secret practices."

Like the court dwarfs painted by Velázquez, he watches the spectacle of worldly power. As in the eyes of the dwarfs, there is an irony in his regard, an irony that pierces any conventional rhetoric. There, however, the resemblance ends, for the dwarfs were handicapped at birth. Each dwarf has his own expression, yet all of them register a form of resignation which declares: This time round, normal life was bound to exclude me. Aesop has no such exemption. He is normal.

The robe clothes him and at the same time reminds us of the naked body underneath. This effect is heightened by his left hand, inside the robe against his stomach. And his face demonstrates something similar concerning his mind. He observes, watches, recognizes, listens to what surrounds him and is exterior to him, and at the same time he ponders within,

* Danilo Dolci, *Sicilian Lives* (New York: Pantheon, 1981), p. 171.

ceaselessly arranging what he has perceived, trying to find a sense which goes beyond the five senses with which he was born. The sense found in what he sees, however precarious and ambiguous it may be, is his only possession. For food or shelter he is obliged to tell one of his stories.

How old is he? Between fifty and sixty-five? Younger than Rembrandt's Homer, older than Ribera's Aesop. Some say the original story-teller lived to the age of seventy-five. Velázquez died at sixty-one. The bodies of the young are gifts—both to themselves and others. The goddesses of ancient Greece were carriers of this gift. The bodies of the powerful, when old, become unfeeling and mute—already resembling the statues which they believe will be their due after their death.

Aesop is no statue. His physique embodies his experience. His presence refers to nothing except what he has felt and seen. Refers to no possessions, to no institution, to no authority or protection. If you weep on his shoulder, you'll weep on the shoulder of his life. If you caress his body, it will still recall the tenderness it knew in childhood.

Ortega y Gasset describes something of what I feel in this man's presence:

> At another time we shall see that, while astronomy for example is not a part of the stellar bodies it researches and discovers, the peculiar vital wisdom we call "life experience" is an essential part of life itself, constituting one of its principal components or factors. It is this wisdom that makes a second love necessarily different from a first one, because the first love is already there and one carries it rolled up within. So if we resort to the image, universal and ancient as you will see, that portrays life as a road to be traveled and traveled again—hence the expressions "the course of life, *curriculum vitae*, decide on

a career"—we could say that in walking along the road of life we keep it with us, know it; that is the road already traveled curls up behind us, rolls up like a film. So that when he comes to the end, man discovers that he carries, stuck there on his back, the entire roll of the life he led.*

He carries the roll of his life with him. His virility has little to do with mastery or heroism, but a lot to do with ingenuity, cunning, a certain mockery and a refusal to compromise. This last refusal is not a question of obstinacy but of having seen enough to know one has nothing to lose. Women often fall in love with energy and disillusion, and in this they are wise for they are doubly protected. This man, elderly, ragged, carrying nothing but his tattered life's work, has been, I believe, memorable to many women. I know old peasant women with faces like his.

He has now lost his male vanity. In the stories he tells he is not the hero. He is the witness become historian, and in the countryside this is the role which old women fill far better than men. Their reputations are behind them and count for nothing. They become almost as large as nature. (There is an art-historical theory that Velázquez, when painting this portrait, was influenced by an engraving by Giovanni Battista Porta which made a physiognomical comparison between the traits of a man and an ox. Who knows? I prefer my recollection of old peasant women.)

His eyes are odd, for they are painted less emphatically than anything else in the picture. You almost have the impression that everything else has been painted *except* his eyes, that they are all that remains of the ground of the canvas.

Yet everything in the picture, apart from the folio and

* José Ortega y Gasset, *Historical Reason* (New York: W. W. Norton, 1984), p. 187.

his hand holding it, points to them. Their expression is given by the way the head is held and by the other features: mouth, nose, brow. The eyes perform—that is to say they look, they observe and little escapes them, yet they do not react with a judgement. This man is neither protagonist nor judge nor satirist. It is interesting to compare Aesop with Velázquez's companion painting (same size and formula) of Menippus. Menippus, one of the early cynics and a satirist, looks out at the world, as at something he has left behind, and his leaving affords him a certain amusement. In his stance and expression there is not a trace of Aesop's compassion.

Indirectly, Aesop's eyes tell a lot about story-telling. Their expression is reflective. Everything he has seen contributes to his sense of the enigma of life: for this enigma he finds partial answers—each story he tells is one—yet each answer, each story, uncovers another question, and so he is continually failing and this failure maintains his curiosity. Without mystery, without curiosity and without the form imposed by a partial answer, there can be no stories—only confessions, communiqués, memories and fragments of autobiographical fantasy which for the moment pass as novels.

I once referred to story-tellers as Death's Secretaries. This was because all stories, before they are narrated, begin with the end. Walter Benjamin said: "Death is the sanction of everything that the story-teller can tell. He has borrowed his authority from death." Yet my phrase was too romantic, not contradictory enough. No man has less to do with death than this one. He watches life as life might watch itself.

A STORY for Aesop. It was the sixth of January, Twelfth Night. I was invited into the kitchen of a house I'd never been into before. Inside were some children and a large, bobtail sheep-dog with a coarse grey coat and matted hair over

59

her eyes. My arrival frightened the dog, and she started to bark. Not savagely but persistently. I tried talking to her. Then I squatted on the floor so as to be the same size as her. Nothing availed. Ill at ease, she went on barking. We sat round the table, eight or nine of us, drank coffee and ate biscuits. I offered her a biscuit at arm's length. Finally, she took it. When I offered her another, close to my knee, she refused. She never bites, said the owner. And this remark prompted me to tell a story.

Twenty-five years ago I lived in a suburb on the edge of a European city. Near the flat were fields and woods where I walked every morning before breakfast. At a certain point, by a makeshift shed where some Spaniards were living, I always passed the same dog. Old, grey, blind in one eye, the size of a boxer, and a mongrel if ever there was one. Each morning, rain or sunny, I would stop, speak to her, pat her head and then continue on my way. We had this ritual. Then one winter's day she was no longer there. To be honest I didn't give it a second thought. On the third day, however, when I approached the shed, I heard a dog's bark and then a whine. I stopped, looked around. Not a trace. Perhaps I had imagined it. Yet no sooner had I taken a few steps than the whining started again, turning into a howl. There was snow on the ground. I couldn't even see the tracks of a dog. I stopped and walked towards the shed. And there, at my feet, was a narrow trench for drain pipes, dug, presumably, before the ground was frozen. Five feet deep with sheer sides. The dog had fallen into the trench and couldn't get out. I hesitated. Should I try to find its owner? Should I jump down and lift it out?

As I walked away, my demon's voice hissed: Coward!

Listen, I replied, she's blind, she's been there for a day or two.

You don't know, hissed the demon.

At least all night, I said. She doesn't know me and I don't even know her name!

Coward!

So I jumped down into the trench. I calmed her. I sat with her till the moment came to lift her up to the level of my shoulders and put her on the ground. She must have weighed a good thirty kilos. As soon as I lifted—as was to be expected—she bit me. Deep into the pad of my thumb and my wrist. I scrambled out and hurried off to the doctor. Later I found the dog's owner, an Italian, and he gave me his card and wrote on the back of it the name and address of his insurance company. When I recounted what had happened to the insurance agent, he raised his eyebrows.

The most improbable story I've ever heard! he said.

I pointed at my bandaged right arm in its sling.

Then you're mad! he said.

The owner of the dog asked me to report to you.

Of course! You're in it together. How much do you earn?

At that moment I was inspired. Ten thousand a month, I lied.

Please take a seat, sir.

The people listening around the table laughed. Somebody else told a story and then we got to our feet, for it was time to go. I walked over to the door, buttoning up my coat. The dog came across the room in a straight line towards me. She took my hand in her mouth, gently, and backed away, tugging.

She wants to show you the stable where she sleeps, said one of the children.

But no, it was not to the stable door the dog was taking me, it was to the chair where I had been sitting. I sat down again and the dog lay down by my feet, undisturbed by the laughter of everyone else in the room and watchful for the smallest sign that I intended to leave.

A small story for Aesop. You can make what you like of it. How much can dogs understand? The story becomes a story because we are not quite sure; because we remain sceptical either way. Life's experience of itself (and what else are stories if not that?) is always sceptical.

LEGEND HAS IT that Pyrrho, the founder of scepticism, was at first a painter. Later he accompanied Alexander the Great on his voyage through Asia, gave up painting and became a philosopher, declaring that appearances and all perceptions were illusory. (One day somebody should write a play about Pyrrho's journey.) Since the fourth century B.C., and more precisely during the last two centuries, the sense of the term "scepticism" has radically changed. The original sceptics rejected any total explanation (or solution) concerning life because they gave priority to their experience that a life really lived was an enigma. They thought of their philosophical opponents as privileged, protected academicians. They spoke for common experience against elitism. They believed that if God existed, he was invisible, unanswerable and certainly didn't belong to those with the longest noses.

Today scepticism has come to imply aloofness, a refusal to be engaged, and very often—as in the case of logical positivism—privileged pedantry. There was a certain historical continuity from the early sceptics through the heretics of the Middle Ages to modern revolutionaries. By contrast, modern scepticism challenges nobody and dismantles only theories of change. This said, the man before us is a sceptic in the original sense.

If I did not know the painting was by Velázquez, I think I would still say it came from Spain. Its intransigence, its austerity and its scepticism are very Spanish. Historically,

Spain is thought of as a country of religious fervour, even fanaticism. How to reconcile this with the scepticism I am insisting upon? Let us begin with geography.

CITIES HAVE always been dependent on the countryside for their food; is it possible that they are similarly dependent on the countryside for much of their ontology, for some of the terms in which they explain man's place in the universe?

It is outside the cities that nature, geography, climate, have their maximum impact. They determine the horizons. Within a city, unless one climbs a tower, there is no horizon.

The rate of technological and political change during our century has made everyone aware of history on a world scale. We feel ourselves to be creatures not only of history but of a universal history. And we are. Yet the supremacy given to the historical has perhaps led us to underestimate the geographical.

In the Sahara one enters the Koran. Islam was born of, and is continually reborn from, a nomadic desert life whose needs it answers, whose anguish it assuages. Already I am writing too abstractly so that one forgets the weight of the sky on the sand or on the rock which has not yet become sand. It is under this weight that a prophetic religion becomes essential. As Edmond Jabes has written:

> In the mountain the sense of infinitude is disciplined
> by heights and depths and by the sheer density of
> what you confront; thus you yourself are limited,
> defined as an object among other objects. At sea there
> is always more than just water and sky; there is the
> boat to define your difference from both, giving you
> a human place to stand. But in the desert the sense

63

of the infinite is unconditional and therefore truest.
In the desert you're left utterly to yourself. And in
that unbroken sameness of sky and sand, you're noth-
ing, absolutely nothing.

The blade (the knife, the sword, the dagger, the sickle)
occupies a special place in Arabic poetry. This is not unrelated
to its usefulness as a weapon and as a tool. Yet the knife-
edge has another meaning too. Why is the knife so true to
this land? Long before the slanders and half-truths of Eu-
ropean Orientalism ("the cruelty of the scimitar"), the blade
was a reminder of the thinness of life. And this thinness
comes, very materially, from the closeness in the desert be-
tween sky and land. Between the two there is just the height
for a horseman to ride or a palm to grow. No more. Existence
is reduced to the narrowest seam, and if you inhabit that
seam, you become aware of life as an astonishing *outside*
choice, of which you are both witness and victim.

Within this awareness there is both fatalism and intense
emotion. Never fatalism and indifference.

"Islam," writes Hasam Saab, "is, in a sense, a passionate
protest against naming anything sacred except God."

In the thin stratum of the living laid on the sand like a
nomad's carpet, no compromise is possible because there are
no hiding places; the directness of the confrontation produces
the emotion, the helplessness, the fatalism.

The interior tableland of Spain is, in a certain sense,
more negative than the desert. The desert promises nothing
and in its negation there are miracles to be found. The Will
of God, the oasis, the alpha, the *ruppe vulgaire*—for example.
The Spanish steppe is a landscape of *broken* promises. Even
the backs of its mountains are broken. The typical form of
the *meseta* is that of a man cut down, a man who has lost his
head and shoulders, truncated by one terrible horizontal blow.
And the geographical repetition of these horizontal cuts in-

terminably underlines how the steppe has been lifted up towards the sky to bake in the summer (it is the horizontals which continually suggest the oven) and to freeze in the winter, coated with ice.

In certain areas the Spanish steppe produces wheat, maize, sunflowers, and vines. But these crops, less tough than briars, thistles or the *jara*, risk being burnt or frozen out. Little lends itself to their survival. They have to labour, like the men who cultivate them, in the face of an inherent hostility. In this land even the rivers are mostly enemies rather than allies. For nine months of the year they are dried-out ravines—obstacles; for two months they are wild, destructive torrents.

The broken promises, like the fallen stones and the salt gravel, appear to guarantee that everything will be burnt to dust, turning first black and then white. And history? Here one learns that history is no more than the dust raised by a flock of sheep. All architecture on the tableland is defensive, all monuments are like forts. To explain this entirely by national military history—the Arab occupation, the Wars of Reconquest—is, I think, too simple. The Arabs introduced light into Spanish architecture. The essential Spanish building, with its massive doors, its defensive walls, its four-facedness and its solitude, is a response to the landscape as representation, a response to what its signs have revealed about the origins of life.

Those who live there and work on this land live in a world visibly without promise. What promises is the invisible and lies behind the apparent. Nature, instead of being compliant, is indifferent. To the question "Why is man here?" it is deaf, and even its silence cannot be counted as a reply. Nature is ultimately dust (the Spanish term for ejaculation is "throwing dust")—in face of which nothing remains except the individual's ferocious faith or pride.

What I am saying here should not be confused with the

character of the Spanish men and women. Spaniards are often more hospitable, truer to their promises, more generous, more tender than many other people. I am not talking about their lives but about the stage on which they live.

In a poem called *Across the Land of Spain* Antonio Machado wrote:

> You will see battle plains and hermit steppes
> —in these fields there is nothing of the garden in
> the Bible—
> here is a land for the eagle, a bit of planet
> crossed by the wandering shadow of Cain.

Another way of defining the Spanish landscape of the interior would be to say that it is unpaintable. And there are virtually no paintings of it. There are of course many more unpaintable landscapes in the world than paintable ones. If we tend to forget this (with our portable easels and colour slides!) it is the result of a kind of Eurocentrism. Where nature on a large scale lends itself to being painted is the exception rather than the rule. (Perhaps I should add that I would be the last to forget about the specific social-historical conjuncture necessary for the production of pure landscape painting, but that is another story.) A landscape is never unpaintable for purely descriptive reasons; it is always because its sense, its meaning, is not *visible*, or else lies elsewhere. For example, a jungle is paintable as a habitation of spirits but not as a tropical forest. For example, all attempts to paint the desert end up as mere paintings of sand. The desert is elsewhere—in the sand drawings of the Australian Aborigines, for instance.

Paintable landscapes are those in which what is visible enhances man—in which natural appearances make *sense*. We see such landscapes around every city in Italian Renais-

sance painting. In such a context there is no distinction be-
tween appearance and essence—such is the classic ideal.

Those brought up in the unpaintable *meseta* of the Span-
ish hinterland are convinced that essence can never be visible.
The essence is in the darkness behind closed lids. In another
poem, called *The Iberian God*, Machado asks:

Who has ever seen the face of the God of Spain?
My heart is waiting
for that Spaniard with rough hands
who will know how to carve from the ilex of Castile
the austere God of that brown earth.

The unpaintability of a landscape is not a question of
mood. A mood changes according to the time of day and
season. The Castilian steppe at noon in summer—desiccated
as a dried fish—is different in mood from the same steppe in
the evening when the broken mountains on the horizon are
as violet as living sea anemones. In Goya's Aragon the summer
dust of endless extension becomes, in the winter when the
north-east *cierzo* is blowing, a frost that blindfolds. The mood
changes. What does not change is the scale, and what I want
to call the *address* of the landscape.

The scale of the Spanish interior is of a kind which offers
no possibility of any focal centre. This means that it does not
lend itself to being looked at. Or, to put it differently, *there
is no place to look at it from*. It surrounds you but it never
faces you. A focal point is like a remark being made to you.
A landscape that has no focal point is like a silence. It con-
stitutes simply a solitude that has turned its back on you.
Not even God is a visual witness there—for God does not
bother to look there, the visible is nothing there. This sur-
rounding solitude of the landscape which has turned its back
is reflected in Spanish music. It is the music of a voice sur-

rounded by emptiness. It is the very opposite of choral music. Profoundly human, it carries like the cry of an animal. Not because the Spaniards are animal-like, but because the territory has the character of an unchartable vastness.

By "address" I mean what a given landscape addresses to the indigenous imagination: the background of meaning which a landscape suggests to those familiar with it. It begins with what the eye sees every dawn, with the degree to which it is blinded at noon, with how it feels assuaged at sunset. All this has a geographical or topographical basis. Yet here we need to understand by geography something larger than what is usually thought. We have to return to an earlier geographical experience, before geography was defined purely as a natural science. The geographical experience of peasants, nomads, hunters—but perhaps also of cosmonauts.

We have to see the geographic as a representation of an invisible origin: a representation which is constant yet always ambiguous and unclear because what it represents is about the beginning and end of everything. What we actually see (mountains, coastlines, hills, clouds, vegetation) are the temporal consequences of a nameless, unimaginable event. We are still living that event, and geography—in the sense I'm using it—offers us signs to read concerning its nature.

Many different things can fill the foreground with meaning: personal memories; practical worries about survival—the fate of a crop, the state of a water supply; the hopes, fears, prides, hatreds, engendered by property rights; the traces of recent events and crimes (in the countryside all over the world crime is one of the favourite subjects of conversation). All these, however, occur against a common constant background which I call the landscape's *address*, consisting of the way a landscape's "character" determines the imagination of those born there.

The address of many jungles is fertile, polytheistic, mortal. The address of deserts is unilinear and severe. The address of western Ireland or Scotland is tidal, recurring, ghost-filled. (This is why it makes sense to talk of a Celtic landscape.) The address of the Spanish interior is timeless, indifferent and galactic.

The scale and the address do not change with mood. Every life remains open to its own accidents and its own purpose. I am suggesting, however, that geography, apart from its obvious effects on the biological, may exercise a cultural influence on how people envisage nature. This influence is a visual one, and since until very recently nature constituted the largest part of what men saw, one can further propose that a certain geography encourages a certain relation to the visible.

Spanish geography encourages a scepticism towards the visible. No sense can be found there. The essence lies elsewhere. The visible is a form of desolation, appearances are a form of debris. What is essential is the invisible self, and what may lie behind appearances. The self and the essential come together in darkness or blinding light.

THE LANGUAGE OF SPANISH PAINTING came from the other side of the Pyrenees. This is to say it was a language originally born of the scientific visual curiosity of the Italian Renaissance and the mercantile realism of the Low Countries. Later this language becomes baroque, then neoclassicist and romantic. But throughout its evolution it remains—even during its mannerist fantasy phrase—a visual language constructed around the credibility of natural appearances and around a three-dimensional materialism. One has only to think of Chinese or Persian or Russian ikonic art to appreciate

more clearly the *substantiality* of the main European tradition. In the history of world art, European painting, from the Renaissance until the end of the nineteenth century, is the most corporeal. This does not necessarily mean the most sensuous, but the most corporeally addressed to the living-within-their-bodies, rather than to the soul, to God, or to the dead.

We can call this corporeality humanist if we strip the word of its moral and ideological connotations. Humanist insofar as it places the living human body at the centre. Such a humanism can only occur, I believe, in a temperate climate within landscapes that lend themselves, when the technological means are available and the social relations permit, to relatively rich harvests. The humanism of the visual language of European painting presumes a benign, kind nature. Perhaps I should emphasise here that I'm talking about the language as such, and not about what can be said with it. Poussin in *Arcadia* and Callot in his *Horrors of War* were using the same language, just as were Bellini with his Madonnas and Grünewald with his victims of the plague.

Spain at the beginning of the sixteenth century was the richest and most powerful country in Europe: the first European power of the Counter-Reformation. During the following centuries of rapid decline and increasing poverty, it nevertheless continued as a nation to play a European role, above all as a defender of the Catholic faith. That its art should be European, that its painters practised in a European language (often working in Italy) is therefore not surprising. Yet just as Spanish Catholicism was unlike that in any other European country, so was its art. The great painters of Spain took European painting and turned it against itself. It was not their aim to do so. Simply, their vision, formed by Spanish experience, could not stomach that painting's humanism. A language of plenty for a land of scarcity. The contrast was

flagrant, and even the obscene wealth of the Spanish church couldn't bridge it. Once again Machado, the greatest poet of Spanish landscape, points a way to an answer:

> O land of Alvorgonzalez,
> In the heart of Spain,
> Sad land, poor land,
> So sad that it has a soul!

THERE IS A CANVAS by El Greco of St. Luke, the patron saint of painters. In one hand he is holding a paintbrush and, in his other, an open book against his torso. We see the page in the book on which there is an image of the Madonna and Child.

Zurbarán painted at least four versions of the face of Christ, printed miraculously on St. Veronica's head-cloth. This was a favourite subject of the Counter-Reformation. The name Veronica, given to the woman who is said to have wiped Christ's face with her scarf as he carried the cross to Golgotha, is doubtless derived from the words *vera icona*, true image.

In the El Greco and the Zurbarán we are reminded of how *thin* even a true image is. As thin as paper or silk.

In bullfighting the famous pass with the cape is called a St. Veronica. The bullfighter holds his cape up before the bull, who believes the cape is the matador. As the bull advances with his head down, the matador slowly withdraws the cape and flaunts it so that it becomes no more than a scrap of material. He repeats this pass again and again, and each time the bull believes in the solidity and corporeality of what has been put before his eyes, and is deceived.

Ribera painted at least five versions of a philosopher hold-

ing a looking-glass, gazing at his own reflection and pondering the enigma of appearances. The philosopher's back is turned to us, so that we see his face properly only in the mirror which offers, once again, an image as thin as its coat of quicksilver.

Another painting by Ribera shows us the blind Isaac blessing his youngest son, Jacob, whom he believes to be Esau. With the connivance of Rebecca, his mother, Jacob is tricking his father with the kidskin he has wrapped around his wrist and arm. The old man, feeling the hairy arm, believes he is blessing Esau his eldest son, the hirsute shepherd. I cannot remember ever seeing another painting of this subject. It is an image devoted to demonstrating graphically how surfaces, like appearances, deceive. Not simply because the surface is superficial, but because it is false. The truth is not only deeper, it is elsewhere.

The iconographic examples I have given prepare the way for a generalization I want to make about *how* the Spanish masters painted—regardless of subject or iconography. If this *how* can be seized, we will come nearer to understanding something intrinsic to the Spanish experience of the momentous and of the everyday. *The Spanish masters painted all appearances as though they were a superficial covering.*

A covering like a veil? Veils are too light, too feminine, too transparent. The covering the painters imagined was opaque. It had to be, for otherwise the darkness it dressed would seep through, and the image would become as black as night.

Like a curtain? A curtain is too heavy, too thick, and it obliterates every texture save its own. According to the Spanish masters, appearances were a kind of skin. I am always haunted by Goya's two paintings *The Maja Dressed* and *The Maja Undressed.* It is significant that this dressed-undressed painting game occurred to a Spaniard, and remains unique

in the history of art—the white skin of the naked maja is as much a covering as was her costume. What she *is* remains undisclosed, invisible.

The appearance of everything—even of rock or of armour—is equally a skin, a membrane. Warm, cold, wrinkled, fresh, dry, humid, soft, hard, jagged, the membrane of the visible covers everything we see with our eyes open, and it deceives us as the cape deceives the bull.

IN SPANISH PAINTING there are very few painted eyes that are openly *looking*. Eyes are there to suggest the inner and invisible spirit of the painted person.

In El Greco they are raised to heaven. In Velázquez— think again of his portraits of the court dwarfs—their eyes are masked from vision as if by a terrible cataract; the eyes of his royal portraits are marvellously painted orbs, jellies, but they do not scrutinize like those painted by Hals, who was his contemporary a thousand miles to the north.

In Ribera and Zurbarán eyes look inward, lost to the world. In Murillo the windows of the soul are decorated with tinsel. Only Goya might seem to be the exception—particularly in the portraits of his friends. But if you place these portraits side by side, a curious thing becomes evident: their eyes have the same expression: an unflinching, lucid resignation—as if they had already seen the unspeakable, as if the existent could no longer surprise them and was scarcely worth observing any more.

Spanish art is often designated as realist. In a sense, it is. The surfaces of the objects painted are studied and rendered with great intensity and directness. The existent is stated, never simply evoked. There is no point in seeing through appearances, because behind them there is nothing

to see. Let the visible be visible without illusion. The truth is elsewhere.

In *The Burial of Count Orgaz*, El Greco paints the armour of the dead count and, reflected on its metal, the image of St. Stephen, who is lifting up the corpse by its legs. In *The Spoliation* he uses the same virtuoso device. On the armour of the knight standing beside Christ is reflected, in gladiola-like flames, the red of the Saviour's robe. In El Greco's "transcendental" world, the sense of touch, and therefore of the tangible reality of surfaces, is everywhere. He had a magnificent wardrobe for dressing up his saints. There's not another garment-painter like him.

In the more austere work of Ribera and Zurbarán, the cloak covers the body, the flesh covers the bones, the skull contains the mind. And the mind is what? Darkness and invisible faith. *Behind* the last surface is the unpaintable. Behind the pigment on the canvas is what counts, and it corresponds to what lies behind the lids of closed eyes.

THE WOUND in Spanish painting is so important because it penetrates appearances, reaches behind them. Likewise the tatters and rags of poverty—of course they reflect both the reality and the cult of poverty, but visually what they do is to tear apart, to reveal the next surface, and so take us nearer to the last, behind which the truth begins.

The Spanish painters, with all their mastery, set out to show that the visible is an illusion, only useful as a reminder of the terror and hope within the invisible. Think, by contrast, of a Piero della Francesca, a Raphael, a Vermeer, in whose work all is visibility and God, above all, is the all-seeing.

Goya—when he was past the age of fifty and deaf—broke the mirror, stripped off the clothes and saw the bodies mu-

tilated. In the face of the first modern war, he found himself
in the darkness, on the far side of the visible, and from there
he looked back on the debris of appearances (if that sounds
like a metaphor, look at the late brush drawings), picked up
the pieces and rearranged them together. Black humour, black
painting, flares in the night of *The Disasters of War* and the
Disparates. (In Spanish *disparate* means "folly," but its Latin
root means "divide, separate.") Goya worked with the scat-
tered, disfigured, hacked, fragments of the visible. Because
they are broken fragments, we see what lies behind: the same
darkness that Zurbarán, Ribalta, Maino, Murillo and Ribera
had always presumed.

Maybe one of the *Disparates* comments on this reversal,
by which the presumed dark behind appearances becomes the
evident dark between their mutilated pieces. It shows a horse
that turns its head to seize between its teeth the rider, who
is a woman in a white dress. That which once you rode
annihilates you.

Yet the reality of what Goya experienced and expressed
is not finally to be found in any symbol, but simply in the
way he drew. He puts parts together without considering the
whole. Anatomy for him is a vain, rationalist exercise that
has nothing to do with the savagery and suffering of bodies.
In front of a drawing by Goya our eyes move from part to
part, from a hand to a foot, from a knee to a shoulder, as
though we were watching an action in a film, as though the
parts, the limbs, were separated not by centimetres but by
seconds.

In 1819, when he was seventy-three, Goya painted *The
Last Communion of St. Joseph de Calasanz*, the founder of a
religious order, who educated the poor for nothing and in one
of whose schools Goya had been educated as a child in Sar-
agossa. In the same year Goya also painted a small picture of
the Agony in the Garden.

In the first painting the old grey-faced, open-mouthed

man kneels before the priest, who is placing the Host on his tongue. Beyond the two foreground figures is the congregation in the dark church: children, several men of different ages, and perhaps, on the extreme left, a self-portrait of the painter. Everything in the painting diminishes before the four pairs of praying hands we can see: the saint's, another old man's, the painter's and a younger man's. They are painted with furious concentration—by the painter who, when he was young, was notorious for the cunning with which he avoided hands in his portraits to save himself time. The fingertips of each pair of hands interlace loosely, and the hands cup with a tenderness that only young mothers and the very old possess, cup—as if protecting the most precious thing in the world—nothing, *nada*.

St. Luke tells the story of Christ on the Mount of Olives in the following words:

> And he came out, and went, as he was wont, to the mount of Olives; and his disciples followed him. And when he was at the place, he said unto them, Pray that ye enter not into temptation. And he was withdrawn from them about a stone's cast, and kneeled down, and prayed, saying Father, if thou be willing, remove this cup from me; nevertheless not my will, but thine, be done. And there appeared an angel unto him from heaven, strengthening him. And being in an agony he prayed more earnestly; and his sweat was as it were great drops of blood falling down to the ground.

Christ is on his knees, arms outstretched, like the prisoner awaiting, for another second, his execution on the Third of May 1808.

It is said that in 1808, when Goya began drawing *The*

Disasters of War, his manservant asked him why he depicted the barbarism of the French. "To tell men eternally," he replied, "not to be barbarians."

The solitary figure of Christ is painted on a ground of black with scrubbed brush marks in pale whites and grays. It has no substance at all. It is like a tattered white rag whose silhouette against the darkness makes the most humanly expressive gesture imaginable. Behind the rag is the invisible.

What makes Spanish painting Spanish is that in it is to be discovered the same anguish as the landscapes of the great *mesa* of the interior often provoked on those who lived and worked among them. In the Spanish galleries of the Prado, in the centre of modern Madrid, a Spanish earth, measured not by metres but by "a stone's cast," on to which sweat falls like drops of blood, is present everywhere, insistent and implicit. The Spanish philosopher Miguel de Unamuno has defined it very exactly: "Suffering is, in effect, the barrier which unconsciousness, matter, sets up against consciousness, spirit; it is the resistance to will, the limit which the visible universe imposes upon God."

VELÁZQUEZ WAS AS CALM as Goya was haunted. Nor are there any signs of religious fervour or passion in his work. His art is the most unprejudiced imaginable—everything he sees receives its due; there is no hierarchy of values. Before his canvases we are not aware of the thinness of surfaces, for his brush is too suave to separate surface from space. His paintings seem to come to our eyes like nature itself, effortlessly. Yet we are disturbed even as we admire. The images, so masterly, so assured, so tactful, have been conceived on a basis of total scepticism.

Unprejudiced, effortless, sceptical—I repeat the epithets

I have used and they yield a sense: an image in a mirror. Velázquez's deliberate use of mirrors in his work has been the subject of several art-historical treatises. What I'm suggesting here, however, is more sweeping. He treated all appearances as being the equivalent of reflections in a mirror. That is the spirit in which he quizzed appearances, and this is why he discovered, long before anyone else, a miraculous, purely optical (as distinct from conceptual) verisimilitude.

But if all appearances are the equivalent of reflections, what lies behind the mirror? Velázquez's scepticism was founded upon his faith in a dualism which declared: Render unto the visible what is seen, and to God what is God's. This is why he could paint so sceptically with such certitude.

Consider Velázquez's canvas which was once called *The Tapestry Makers* and is now entitled *The Fable of Arachne*. It was always thought to be one of the painter's last works, but recently certain art historians (for reasons which to me are not very convincing) have dated it ten years earlier. In any case everyone is agreed that it is the nearest thing we have to a testament from Velázquez. Here he reflects upon the practice of image-making.

The story of Arachne, as related by Ovid, tells how a Lydian girl (we see her on the right, winding a skein of wool into a ball) made such famous and beautiful tapestries that she challenged the goddess of the arts and crafts, Pallas, to a contest. Each had to weave six tapestries. Pallas inevitably won and, as a punishment, turned Arachne into a spider. (The story is already contained in her name.) In the painting by Velázquez both are at work (the woman on the left at the spinning wheel is Pallas) and in the background in the lighted alcove there is a tapestry by Arachne which vaguely refers to Titian's painting *The Rape of Europa*. Titian was the painter whom Velázquez most admired.

Velázquez's canvas was originally somewhat smaller.

Strips were added to the top and the left and the right in the eighteenth century. The overall significance of the scene, however, has not been changed. Everything we see happening is related to what we can call the cloth or the garment of appearances. We see the visible being created from spun thread. The rest is darkness.

Let us move across the foreground from left to right. A woman holds back a heavy red curtain as if to remind the spectator that what she or he is seeing is only a temporary revelation. Cry "Curtain!" and everything disappears as off a stage.

Behind this woman is a pile of unused coloured cloths (a stock of appearances not yet displayed) and, behind that, a ladder up which one climbs into darkness.

Pallas at the spinning wheel spins a thread out of the debris of sheared wool. Such threads, when woven, can become a kerchief like the one she is wearing on her head. Equally, the golden threads, when woven, can become flesh. Look at the thread between her finger and thumb and consider its relation to her bare, outstretched leg.

To the right, seated on the floor, another woman is carding the wool, preparing it for the life it will assume. With Arachne, winding a skein of spun wool into a ball with her back to us, we have an ever-clearer allusion as to how the thread can become either cloth or flesh. The skein, her out-stretched arm, the shirt on her back, her shoulders, are all made of the same golden stuff, partaking of the same life: whilst hanging on the wall behind we see the dead, inert material of the sheep's wool before it has acquired life or form. Finally, on the extreme right, the fifth woman carries a basket from which flows a golden, diaphanous drapery, like a kind of surplus.

To underline even further the equivalence of flesh and cloth, appearance and image, Velázquez has made it impos-

79

sible for us to be sure which figures in the alcove are woven into the tapestry and which are free-standing and "real." Is the helmeted figure of Pallas part of the tapestry or is she standing in front of it? We are not sure. The ambiguity with which Velázquez plays here is of course a very old one. In Islamic and Greek and Indian theology the weaver's loom stands for the universe and the thread for the thread of life. Yet what is specific and original about this painting in the Prado is that everything in it is revealed against a background of darkness, thus making us acutely aware of the *thinness* of the tapestry and therefore of the *thinness* of the visible. We come back, despite all the signs of wealth, to the rag.

Before this painting by Velázquez we are reminded of Shakespeare's recurring comparison of life with a play.

> . . . These our actors,
> As I foretold you, were all spirits and
> Are melted into air, into thin air:
> And, like the baseless fabric of this vision,
> The cloud-capped towers, the gorgeous palaces
> The solemn temples, the great globe itself,
> Yea, all which it inherit, shall dissolve
> And, like this insubstantial pageant faded,
> Leave not a rack behind. . . .

This famous quotation (Shakespeare died at the age of fifty-two, when Velázquez was seventeen) leads us back to the scepticism of which I have already spoken. Spanish painting is unique in both its faithfulness and its scepticism towards the visible. Such scepticism is embodied in the story-teller standing before us.

Looking at him, I am reminded that I am not the first to pose unanswerable questions to myself, and I begin to share

something of his composure: a curious composure for it co-exists with hurt, with pain and with compassion. The last, essential for story-telling, is the complement of the original scepticism: a tenderness for experience, because it is human. Moralists, politicians, merchants ignore experience, being exclusively concerned with actions and products. Most literature has been made by the disinherited or the exiled. Both states fix the attention upon experience and thus on the need to redeem it from oblivion, to hold it tight in the dark.

He is no longer a stranger. I begin, immodestly, to identify with him. Is he what I have wanted to be? Was the doorway he appeared in during my childhood simply my wished-for future? Where exactly is he?

One might have expected it from Velázquez! I think he's in front of a mirror. I think the entire painting is a reflection. Aesop is looking at himself. Sardonically, for his imagination is already elsewhere. In a minute he will turn and join his public. In a minute the mirror will reflect an empty room, through whose wall the sound of occasional laughter will be heard.

THE
IDEAL PALACE

A DETAIL OF THE IDEAL PALACE BY THE FACTEUR CHEVAL.

Very few peasants become artists—occasionally perhaps the son or daughter of peasants has done so. This is not a question of talent, but of opportunity and free time. There are some songs and, recently, a few autobiographies about peasant experience. There is the marvellous philosophical work of Gaston Bachelard. Otherwise there is very little. This lack means that the peasant's soul is as unfamiliar or unknown to most urban people as is his physical endurance and the material conditions of his labour.

It is true that in medieval Europe peasants sometimes became artisans, masons, even sculptors. But they were then employed to express the ideology of the Church, not, directly, their own view of the world.

There is, however, one colossal work, which resembles no other and which is a direct expression of peasant experience. It is about this work—which includes poetry, sculpture, architecture—that I want now to talk.

A country postman, as my 27,000 comrades, I walked each day from Hauterives to Tersanne—in the region where there are still traces of the time when the sea was here—sometimes going through snow and ice, sometimes through flowers. What can a man do when walking everlastingly through the same setting, except to dream? I built in my dreams a palace passing

83

all imagination, everything that the genius of a simple man can conceive—with gardens, grottoes, towers, castles, museums and statues: all so beautiful and graphic that the picture of it was to live in my mind for at least ten years. . . .

When I had almost forgotten my dream, and it was the last thing I was thinking about, it was my foot which brought it all back to me. My foot caught on something which almost made me fall: I wanted to know what it was: it was a stone of such strange shape that I put it in my pocket to admire at leisure. The next day, passing through the same place, I found some more, which were even more beautiful. I arranged them together there and then on the spot and was amazed. . . . I searched the ravines, the hillside, the most barren and desolate places. . . . I found tufa which had been petrified by water and which is also wonderful. . . .

This is where my trials and tribulations began. I then brought along some baskets. Apart from the 30 km a day as postman, I covered dozens with my basket on my back, full of stones. Each commune has its own particular type of very hard stone. As I crossed the countryside I used to make small piles of these stones: in the evenings, I returned with my wheelbarrow to fetch them. The nearest were four to five km away, sometimes ten. I sometimes set out at two or three in the morning.

The writer is Ferdinand Cheval, who was born in 1836 and died in 1924, and who spent thirty-three years building his "palace passing all imagination." It is still to be found in Hauterives, the village where he was born, in the Department of the Drôme, France.

In the evening when night has fallen,
And other men are resting.
I work at my palace.
No one will know my suffering.
In the minutes of leisure
Which my duty allows me
I have built this palace of a thousand and one
 nights—
I have carved my own monument

Today the Palace is crumbling, its sculptures disinte-
grating, and its texts, inscribed on or cut into the walls, are
being slowly effaced. It is less than eighty years old. Most
buildings and sculptures fare better, because they belong to
a mainstream tradition which lays down principles for whom
they should be made, and, afterwards, for how they should
be preserved. This work is naked and without tradition be-
cause it is the work of a single "mad" peasant.

There are now a number of books of photographs about
the Palace but the trouble with photographs—and even in
film—is that the viewer stays in his chair. And the Palace is
about the experience of being inside itself. You do not *look*
at it any more than you look at a forest. You either enter it
or you pass it by.

As Cheval has explained, the origin of its imagery was
stones: stones which, shaped during geological times, ap-
peared to him as caricatures. "Strange sculptures of all kinds
of animals and caricatures. Impossible for man to imitate. I
said to myself: since nature wants to make sculpture, I will
make the masonry and architecture for it." As you look *into*
these stones, they become creatures, mostly birds or animals.
Some look at you. Some you only glimpse as they disappear
back into the stones from which they emerged briefly as pro-
files. The Palace is full of a life that is never entirely visible.

Except for a few exceptions which I will discuss later, there are no definitively exterior surfaces. Every surface refers, for its reality, inwards. The animals return to within the stones; when you are not looking, they re-emerge. Every appearance changes. Yet it would be wrong to think of the Palace as dream-like. This was the mistake of the Surrealists, who were the first to "discover" it in the thirties. To psychologize it, to question Cheval's unconscious is to think in terms which never explain its uniqueness.

DESPITE ITS TITLE, its model is not a palace but a forest. Within it are contained many smaller palaces, chateaux, temples, houses, lairs, earths, nests, holes, etc. The full content or population of the Palace is impossible to establish. Each time you enter it, you see something more or different. Cheval ended up by doing far more than just making the masonry and architecture for the sculptures of nature. He began to make his own. But nature remained his model: not as a depository of fixed appearances, not as the source of all taxonomy, but as an example of continual metamorphosis. If I look immediately in front of me now, I see:

a pine tree
a calf, large enough for the pine tree to be its horn
a snake
a Roman vase
two washerwomen, the size of moles
an otter
a lighthouse
a snail
three friends nestling in coral
a leopard, larger than the lighthouse
a crow

Such a list would have to be multiplied several thousand times in order to make even a first approximate census. And as soon as you realize that, you realize how foreign to the spirit of the work such an exercise would be. Its function is not to present but to surround.

Whether you climb up its towers, walk through its crypts or look up at a façade from the ground, you are aware of having *entered* something. You find yourself in a system which includes the space you occupy. The system may change its own image, suggesting different metaphors at different times. I have already compared it with a forest. In parts it is like a stomach. In other parts it is like a brain—the physical organ in the skull, not the abstract *mind*.

What surrounds you has a physical reality. It is constructed of sandstone, tufa, quicklime, sand, shells and fossils. At the same time, all this diverse material is unified and made mysteriously figurative. I do not now speak of the population of its images. I speak of the mineral material as a whole being arranged to represent a living organic system.

A kind of tissue connects everything. You can think of it as consisting of leaves, folds, follicles, or cells. All Cheval's sustained energy, all his faith, went into creating this. It is in this tissue that you feel the actual rhythm of his movements as he moulded the cement or placed his stones. It was in seeing this tissue grow beneath his hands that he was confirmed. It is this tissue which surrounds you like a womb.

I SAID THE BASIC UNIT of this tissue suggested a kind of leaf or fold. Perhaps the closest I can get to defining it, or fully imagining it—inside the Palace or far away—is to think of the ideal leaf which Goethe writes about in his essay "On the Metamorphosis of Plants." From this archetypal leaf all plant forms derived.

In the Palace this basic unit implies a process of reproduction: not the reproduction of appearances: the reproduction of itself in growth.

CHEVAL LEFT THE DRÔME once in his life: as a young man to work for a few months in Algeria. He gained his knowledge of the world via the new popular encyclopaedic magazines which came on the market during the second quarter of the nineteenth century. This knowledge enabled him to aspire to a world, as distinct from a local and partial, view. (Today modern means of communication are having, in different parts of the world, a comparable political effect. Peasants will eventually visualize themselves in global terms.)

Without a global aspiration, Cheval could never have sustained the necessary confidence to work alone for thirty-three years. In the Middle Ages the Church had offered a universal view, but its craftsmen mostly worked within the constraint of a prescribed iconography in which the peasant view had a place but was not formative. Cheval emerged, alone, to confront the modern world with his peasant vision intact. And according to this vision he built his Palace.

It was an incredibly improbable event, depending on so many contingencies. Of temperament. Of geography. Of social circumstance. The fact, for instance, that he was a postman and so had a small pension. If he had been a peasant working his own land, he could never have afforded the 93,000 hours spent on the Palace. Yet he remained organically and consciously a member of the class into which he was born. "Son of a peasant, it is as a peasant that I wish to live and die in order to prove that in my class too there are men of energy and genius."

The character of the Palace is determined by two essential

qualities: physicality (it contains no abstract sentimental appeals, and Cheval's statements all emphasize the enormous physical labour of its construction) and innerness (its total emphasis on what is within and being within). Such a combination does not exist in modern urban experience but is profoundly typical of peasant experience.

The notion of the *visceral* may perhaps be used here as an example. A word of warning, however, is necessary. To think of peasant attitudes as being more 'gutsy' than urban ones is to miss the point and to resort to an ignorant cliché.

A stable door. Hanging from a nail, a young goat being skinned and eviscerated by a grandfather deploying the point of his pocket-knife with the greatest delicacy, as if it were a needle. Beside him the grandmother holding the intestines in her arms to make it easier for her husband to detach the stomach without perforating it. One yard in front, sitting on the ground, oblivious for a moment of his grandparents, a four-year-old grandson, playing with a cat and rubbing its nose against his own. The visceral is an everyday, familiar category from an early age to peasants.

By contrast, the urban horror of the visceral is encouraged by unfamiliarity, and is linked with urban attitudes to death and birth. Both have become secret, removed moments. In both it is impossible to deny the primacy of inner, invisible processes.

The ideal urban surface is a brilliant one (e.g., chrome) which reflects what is in front of it, and seems to deny that there is anything visible behind it. Its antithesis is the flank of a body rising and falling as it breathes. Urban experience concentrates on recognizing what is outside for what it is, measuring it, testing it and treating it. When what is inside has to be explained (I am not talking now in terms of molecular biology but in terms of everyday life), it is explained as a mechanism, yet the measures of the mechanics used always

belong to the outside. The outside, the exterior, is celebrated by continuous visual reproduction (duplication) and justified by empiricism.

To the peasant the empirical is naive. He works with the never entirely predictable, the emergent. What is visible is usually a sign for him of the state of the invisible. He touches surfaces to form in his mind a better picture of what lies behind them. Above all, he is aware of following and modifying processes which are beyond him, or anybody, to start or stop: he is always aware of being within a process himself.

A factory line produces a series of identical products. But no two fields, no two sheep, no two trees are alike. (The catastrophes of the green revolution, when agricultural production is planned from above by city experts, are usually the result of ignoring specific local conditions, of defying the laws of natural heterogeneity.) The computer has become the storehouse, the "memory" of modern urban information: in peasant cultures the equivalent storehouse is an oral tradition handed down through generations; yet the real difference between them is this: the computer supplies, very swiftly, the exact answer to a complex question; the oral tradition supplies an ambiguous answer—sometimes even in the form of a riddle—to a common practical question. Truth as a certainty. Truth as an uncertainty.

Peasants are thought of as being traditionalists when placed in historical time; but they are far more accustomed to living with change in cyclical time.

A closeness to what is unpredictable, invisible, uncontrollable and cyclic predisposes the mind to a religious interpretation of the world. The peasant does not believe that Progress is pushing back the frontiers of the unknown, because he does not accept the strategic diagram implied by such a statement. In his experience the unknown is constant and central: knowledge surrounds it but will never eliminate

it. It is not possible to generalize about the role of religion among peasants but one can say that it articulates another profound experience: their experience of production through work.

I HAVE SAID that a few surfaces in Cheval's Palace do not refer inwards for their reality. These include the surfaces of some of the buildings he reproduces, like the White House in Washington, D.C., the Maison-Carrée in Algiers. The others are the surfaces of human faces. All of them are enigmatic. The human faces hide their secrets, and it is possible, as with nothing else in the Palace, that their secrets are unnatural. He has sculpted them with respect and suspicion.

Cheval himself called his Palace a temple to nature. Not a temple to the nature of travellers, landscapists, or even Jean-Jacques Rousseau, but to nature as dreamt by a genius expressing the vision of a class of cunning, hardened survivors.

In the centre of the Palace is a crypt, surrounded by sculpted animals—only towards his animals did Cheval show his capacity for tenderness. Between the animals are shells, stones with eyes hidden in them, and, linking everything, the tissue of the first leaf. On the ceiling of this crypt, in the form of a circle, Cheval wrote, "Here I wanted to sleep."

ORLANDO LETELIER ARRESTED IN 1973 DURING THE COUP
DIRECTED BY GENERAL UGARTE PINOCHET.

92

ORLANDO LETELIER,

1932-1976

APPOINTED *Chile's Socialist minister of defence by Al-*
lende in 1973. Marched from his ministry at gunpoint during the
coup, 11 September 1973. Taken to Dawson Island, tortured,
his fingers broken (he played the guitar). Released a year later.
Emigrated to the USA. Elected director of the Transnational
Institute of Amsterdam and Washington, 1976. Travelled
throughout the world to tell people the truth about what was
happening in his country. Blown up in his car in Washington,
D.C., by Cuban exiles acting under the orders of Pinochet's secret
police. It was 21 September 1976. I heard the news two days
later, on the day my son Yves was born. I wrote this poem that
night.

> Once I will visit you
> he said
> in your mountains
> today
> assassinated
> blown to pieces
> he has come to stay
> he lived in many places
> and he died everywhere
> in this room
> he has come between the pages
> of open books

there's not a single apple
on the trees
loaded with fruit this year
which he has not counted
apples the colour of gifts
he faces death no more
there's not a precipice
over which his corpse
has not been hurled
the silence of his voice
tidy and sweet as the leaf of a beech
will be safe in the forest
I never heard him speak
in his mother tongue
except when he named the names
of patriots
the clouds race over the grass
faster than sheep
never lost
he consulted the compass of his heart
always accurate
took bearings from the needle of Chile
and the eye of Santiago
through which he has now passed.

Before the fortress of injustice
he brought many together
with the delicacy of reason
and spoke there
of what must be done
amongst the rocks
not by giants
but by women and men
they blew him to pieces

because he was too coherent
they made the bomb
because he was too fastidious
what his assassins whisper to themselves
his voice could never have said
afraid of his belief
in history
they chose the day of his murder.

He has come
as the season turns
at the moment of the blood red rowanberry
he endured the time without seasons
which belongs to the torturers
he will be here too
in the spring
every spring
until the seasons returning
explode
in Santiago.

IMAGINE PARIS

97

IN THE PLACE DU TERTRE, behind the Sacré-Coeur, which dominates the northern skyline of Paris, dozens of painters display their canvases of the Seine, the Notre Dame, the Boulevards. Cheap, kitsch and in real oil paint. Not entirely insincere, however. The intentions of poor art are simply kinder than those of great art. One or two tourists occasionally buy a canvas, but the more interesting trade is in portraits.

Strolling between the café tables of the little *place*, other painters politely accost the foreign and provincial visitors. A drawing while you wait in charcoal or Conté. The price may be as high as a hundred dollars. A surprising number of tourists agree, stand on the street corner for a quarter of an hour to be drawn, pay up, and go away happy. Why?

The answer has to lead us to another question. Why do people visit art galleries all over the world? Art appreciation? I don't believe it. People really go to the great museums to look at those who once lived, to look at the dead. By the same token, the tourists who pose, standing still for a long quarter of an hour on a sidewalk in the Place du Tertre, believe that their likeness, if "caught," is already being preserved for the future, their old age, their grandchildren. A hundred dollars to be there when the angels come marching in is not so expensive.

What of course is derisory in this commerce is the carefully encouraged hint that the portraits being made in the

Place du Tertre have somehow been "authenticated" by Renoir, Van Gogh, Utrillo, Picasso and all the other great painters who, half a century or more ago, worked and drank and went hungry in the same quarter, within shouting distance of the little *place*. This, however, is an art-critical point, and has little to do with the ontological wager that a likeness, once caught, carries the mystery of a Being.

The mystery of Paris. How can I draw a likeness of the city? Not the official one, stamped on the coins of history. Something more intimate. The date of my birth shows that I was conceived in a hotel somewhere between the Madeleine and the Opéra.

The Madeleine was much admired when it was built in the nineteenth century because it resembled a bank more than a church. It was a monument to worldliness, keeping a proper distance from the original Madeleine's washing of a preacher's dusty feet. Today, inside, it is like a half-empty warehouse for every sort of broken public promise.

I prefer to think that the hotel in 1926 was nearer to the Opéra. Perhaps where, today, two storeys down in a basement, there's a tea-dance every afternoon. The strobing coloured lights gyrate in a circle; the mirror wall along the side of the dance floor reflects the turning dancers. The music is retro—waltzes, tangos, foxtrots. It's an old-fashioned Aladdin's cave of glitter, where time, dates, age, are put aside (not forgotten) between 4 and 7 P.M.

Men of a certain age in well-cut suits come to relax and dance with women they've never met before. The women, younger, genteel and a little disappointed with life, come in the hope of meeting a kind widower. They are not tarts. They dream of becoming wives or understanding mistresses. There's a bar, but scarely anyone drinks. The first pleasure is dancing, and everyone dances exceptionally well.

Both the women and the men pride themselves on being

experts in life without illusion. In this expertise there is a typical Parisian fastidiousness. A chic. What is touching is that, entwined with the music, between 4 and 7 P.M., an unreasonable hope still intermittently flickers and persists there.

In 1926 when I was conceived, I was a hope without any expertise, embalmed in sweet illusions, for my parents were not Parisians. To them the city was a simple honeymoon. To me it's the capital of the country in which I've lived for twenty-five years. Yet what distinguishes Paris from any other city has perhaps not changed so much. How to draw its likeness?

Take the first metro from a suburb early on a summer morning. The first swallows flying. The dustbins under the trees not yet emptied. An incongruous small cornfield between apartment blocks. The suburbs of Paris demand a portrait to themselves. Among them you find the only remaining details from the world as painted by the Impressionists. They are anachronistic, makeshift and look as if they've been constructed out of contraband. They were marginal long before the word became fashionable. A man sleepily clipping the hedge of his tiny front garden, still in his pyjamas. Beehives. A take-away hamburger counter, not yet open, but with the smell of yesterday's oil. Rich Parisians don't live in the suburbs: they live in the center. Take the train.

There's little traffic there yet. The cars parked along the streets are like silent toy ones. On a corner the smell of fresh croissants wafts from a patisserie. Time to get dressed. In a greengrocer's shop two men are arranging fruit and vegetables as if they were millinery. An uncle in a café is looking through a magnifying glass at the stock prices in the morning paper. He doesn't have to ask for the cup of coffee which is brought to him. The last street is being washed. Where's the towel, Maman?

This strange question floats into the mind because the heart of Paris is like nothing so much as the unending interior of a house. Buildings become furniture, courtyards become carpets and arrases, the streets are like galleries, the boulevards conservatories. It is a house, one or two centuries old, rich, bourgeois, distinguished. The only way of going out, or shutting the door behind you, is to leave the centre.

The vast number of little shops, artisans, boutiques, constitute the staff of the house, its servants, there day and night for its hourly upkeep. Their skills are curiously interrelated: hairdressing and carving, needlework and carpentry, tailoring and masonry, lace-making and wrought-iron work, dressmaking and painting. Paris is a mansion. Its dreams are the most urban and the most furnished in the world.

Sufficient to look at Balzac's study. (Now a museum in the Rue Raynouard, 16ème.) The room is not extravagant. Far from it. But it is furnished, enclosed, papered, polished, and inlaid to a degree that would make anybody but a Parisian very claustrophobic. Yet this is highly appropriate to the city's imagination: Balzac's novels are about property, the human heart, destiny, and the natural meeting place for all these forces in Paris is the *salon*. The battlefields are beds, carpets, counters. Everything made in Paris is for indoor use. Even the marvelous silvery light of the typical Paris sky is like a framed skylight.

Who lives in this mansion which is Paris? Every city has a sex and an age which have nothing to do with demography. Rome is feminine. So is Odessa. London is a teenager, an urchin, and, in this, hasn't changed since the time of Dickens.

Paris, I believe, is a man in his twenties in love with an older woman. Somewhat spoilt by his mother, not so much with kisses as with purchases: well-cooked food, fine shoes, after-shave lotion, leather-bound books, chic envelopes. He

discusses everything, he is handsome—perhaps, for once, the word "debonaire" is the right one, and he has a special courage: life is enacted on a stage and he wishes to be exemplary, whatever the risk. His father was his first example of an Expert. Now he has become one himself. There's a complicity between the two men, but also a slight anxiety, for they risk having the same mistress. She also is Paris, and if every city has its own unique smile, in Paris it is hers.

I try to think of a well-known painting containing such a smile but cannot find one. Walking in the city, you see it often. The Boulevard de Charonne is working-class, hot in summer, without shade. A large woman in a floral dress with hefty arms is drinking a beer on the sidewalk at a café table. Under the table is a black mongrel dog with pointed ears to whom she feeds the peanuts she has bought from a machine. A neighbour passes, stops at the table. The woman goes to the counter to buy her friend a lemonade. "She's pretty, your Maman!" says the neighbour to the dog. When the woman comes back with the lemonade, her friend, laughing, says to her: "I'd be happy to be guided by you—so long as the lead wasn't too short!" And the woman in the floral dress, who must be in her seventies, smiles that inimitable smile of indulgent but lucid experience.

Often cemeteries are unexpectedly revealing about the life of the living. And this is true of the Père Lachaise. One needs a map, for it is large. Sections are built like towns—with streets, crossroads, pavements: each house is a tomb or a mausoleum. The dead rest there in furnished property, still protected from the vast exterior. Each tomb has a licence and a number: Concession Perpétuelle Numéro . . . It is the most urban and the most secular cemetery.

Where, for example, would you find a father's grave with an inscription ordered by the family declaring: "President of the Society of High Class Masculine Hairdressing. World Champion. 1950–80"?

A shrine of property this cemetery, certainly. But also one of popular heroes: the last 147 Communards summarily shot against a wall here in 1871; Sarah Bernhardt; Edith Piaf; Chopin. Every day people come to visit them and to listen to their silence.

There is also another, more mysterious shrine, which is our reason for coming: the grave of Victor Noir. In 1870, Prince Pierre Bonaparte, cousin of Emperor Napoleon III, wrote an article in a reactionary Corsican journal attacking the good faith of the radical Paris paper called *La Revanche*. The editor sent Victor Noir and another journalist to ask the prince for an apology. Instead, Pierre Bonaparte seized his pistol and shot Victor Noir dead. The popular outrage provoked by this murder of political pique transformed a relatively unknown young man into a national hero, and the sculptor Jules Dalou made an effigy for his tombstone. Life-size, cast in bronze, it shows Victor Noir—twenty-two years old—dead on the ground, an instant after the pistol shot has been fired. Division ninety-two, Père Lachaise.

Dalou was a realist, making in sculpture works whose vision has something in common with Courbet's paintings: the same kind of fullness in the bodies and limbs depicted, the same close attention to realistic details of costume, a similar corporeal weight. The two artists were friends and both had to go into exile after the fall of the Commune, which they had actively supported.

Victor Noir lies there with the abandon of the two girls in Courbet's *Demoiselles au Bord de la Seine*. The only difference being that the man has died at that very instant— his blood still hot—whereas the girls are overcome by drowsiness and the langour of their day-dreams.

An elegant tall hat lies on the ground beside him. His handsome face is still proud of his own courage, believing it will be rewarded by the love of women. (Each generation of young men knows that, from time to time, the mansion is

transformed into an improvised theatre, on whose stage history is played out—often to the death.) His coat is open, the top button of his tight trousers is undone. His soft-skinned, well-manicured hands lie unclenched, expecting to touch or be touched only by what is fine.

The effigy is moving and strange in its integrity, for it gives the impression that the death it shows has somewhere been selected with the same fastidiousness as the shirt or boots.

Beneath the sky of the cemetery the bronze has turned a dull green. In three places, however, the metal is shiny and gold-coloured where it has been polished by innumerable caresses and kisses. For certain sections of the populace, Victor Noir has become a talisman, a fetish, promising fertility, potency, success, continuity. People come all the while to seek his aid, to touch his example.

The three places where the bronze metal shines are his mouth, the pointed toes of his superbly elegant boots and, most brilliantly of all, the protuberance which his sex makes against his tight trousers.

Perhaps a likeness of the city of Paris begins there in the south-east corner of the Père Lachaise cemetery. . . .

A KIND OF
SHARING

JACKSON POLLOCK AND LEE KRASNER, 1950. PHOTO BY HANS NAMUTH.

THE SUICIDE OF AN ART is a strange idea. Yet I am bound to start with it, if I'm to talk about the story of Jackson Pollock and his wife, the painter Lee Krasner. Krasner outlived her husband by nearly thirty years and went on working as a considerable painter in her own right until 1984. Now, however, I want to concentrate on the fifteen years during which the two of them lived and worked together and Pollock made a bid to change the course of what was then thought of as modern art.

Pollock died thirty-five years ago in a car accident near his house in Springs on Long Island, New York. This wasn't the suicide. He was forty-four years old and he had already been acclaimed the first great American painter. The tragedy of his death, even if foreseeable, obscured for most the suicide of the art.

Born in 1912, Pollock was the youngest of five children of a poorish Irish-Scots Presbyterian family, living mostly in Arizona. He revealed a clumsy but passionate talent early on. Talent doesn't necessarily mean facility. It's a kind of motor activity within a temperament—a form of energy. Pollock's talent was immediately recognized by his teacher, Thomas Hart Benton, the country folk painter.

Pollock was slim, handsome, aggressive, brooding: deeply ambitious to prove he was not a failure and perhaps to earn, at last, his stern mother's approval. In everything he did there

was a touch of charisma, and, following everything he did, a nagging doubt. He was more or less an alcoholic before he was twenty.

As a teenager he dropped his first name, Paul, and used only his second name, Jackson. The change says a lot about the persona he was already being driven into. Jackson Pollock was a name for fighting in the ring. A champ's name.

His later fame as a painter produced the legend that at heart Pollock was a cowboy. Compared to his first collector, Peggy Guggenheim, or to his first apologist, Clement Greenberg, or to the art critic Harold Rosenberg, who invented the term "action painter" for him, he was indeed a goy and a redneck. He hated verbal theories, he didn't read much, he'd never travelled outside the states, he punched people up, and when he was drunk at parties, he pissed into the fireplace. But whatever miracles cowboys may achieve with lassos, no cowboy could dream of controlling paint as Pollock did. This needs repeating several times because with his notorious drip paintings he came to be thought of by some as a dripster, a drooler, a mere pourer. Nothing could be further from the truth. The suicide was committed with mastery, and the desperation was very precise.

Pollock found himself as a painter during the 1940s. At that time most avant-garde painters in the United States were interested in Picasso, surrealism, the Jungian unconscious, the inner self, abstraction. Direct painted references to the objective visible world were usually dismissed as "illustrative." The trip was inwards, an uneasy quest for the soul.

In 1943 the well-known painter Hans Hofmann asked the young Pollock how important nature was for his art. "I am nature," replied Pollock. The older painter was shocked by the arrogance of the reply and Pollock, sensing this, rubbed salt into the wound by adding: "Your theories don't interest

me! Put up or shut up! Let's see your work!" The reply may or may not have been arrogant, but, more significantly, it carried within itself the fatality to come.

Six years later Harold Rosenberg, thinking of Pollock and praising him, wrote: "The modern painter begins with nothingness. That is the only thing he copies. The rest he invents."

AT THIS MOMENT, what was happening in the outside world? For a cultural climate is never separate from events. The United States had emerged from the war as the most powerful nation in the world. The first atom bomb had been dropped. The apocalypse of the Cold War had been placed on the agenda. McCarthy was inventing his traitors. The mood in the country that had suffered least from the war was defiant, violent, haunted. The play most apt to the period would have been Macbeth, and the ghosts were from Hiroshima.

The word "freedom" was being bandied about a lot at the time and meant many different things. It's worth considering three different kinds of freedom, for, put together, they may conjure up something of the stridency of the period. Time was short in the U.S. There was very little patience. The stakes were down. There was an inarticulate sense of loss, often expressed with anger or violence. Vietnam was one of the historical tragedies which would eventually follow from this insecurity.

Freedom of the market. The New York artists were working, more crudely than ever before, for an expanding free market. They painted exactly what they wanted, the size they wanted, with the materials they wanted. Their finished works, scarcely dry, were then put up for sale, promoted, sometimes bought. Bought by collectors—and for the first

time whilst, as it were, still wet—by museums. The competition, however, was ruthless and aggressive. The latest was always at a premium. Gallery fashions changed quickly. Recognition (being featured in *Life*) was dramatic but short-lived. The risks were high and the casualties many. Gorky and Rothko killed themselves. Kline, Reinhardt and Newman died young. Nearly all the painters drank heavily to protect their nerves, for finally their works, transformed into extraordinary property investments, benefited from far more security measures than their working lives. They lived on success and despair.

Next, the freedom the artists were seeking within themselves. As a mixed show catalogue statement put it: "The past decade in America has been a period of great creative activity in painting. Only now has there been a concerted effort to abandon the tyranny of the object and the sickness of naturalism to enter within consciousness." Entering into consciousness—an obscure phrase—meant trying to be oneself on the canvas, without the props of a single familiar reference, and thus to be free of rhetoric, history, convention, other people, safety, the past. Perhaps in a foul world these men were seeking purity.

Then there was the freedom of the Voice of America, the freedom of the Free World. By 1948 the United States needed an international cultural prestige to offset its military and political power: it needed a sophisticated reply to the slogans of "Yankee Go Home!" This is why the CIA during the fifties and sixties covertly supported a multitude of initiatives whose aim was to present the new American art across the world as a promise for the future. Since the works (de Kooning apart) were abstract, they lent themselves to diverse interpretations.

In this way a mostly desperate body of art, which had at first shocked the American public, was transformed by

speeches, articles and the context in which it was displayed, into an ideological weapon for the defence of individualism and the right to express oneself. Pollock, I'm sure, was unaware of this programme—he died too soon; nevertheless, the propaganda apparatus helped to create the confusion surrounding his art after his death. A cry of despair was turned into a declaration for democracy.

IN 1950 HANS NAMUTH made a film of Pollock painting. Pollock puts on his paint-spattered boots—which appear as a kind of homage to Van Gogh—and then he starts to walk around the unprimed canvas laid out on the earth. With a stick he flicks paint on to it from a can. Threads of paint. Different colours. Making a net. Making knots. His gestures are slow but follow one another swiftly. Next he uses the same technique but this time on to a sheet of transparent glass placed on trestles, which allows the photographer to film the act through the glass, so that we see the paint falling around the pebbles and wires already placed on the glass. We look towards the painter from the painting's point of view. We look out from behind to the front where everything is happening. The way he moves his arms and shoulders suggests something between a marksman and a beekeeper putting a swarm into a hive. It is a star performance.

It was probably this film which prompted the phrase "action painting." The canvas, according to this definition, becomes an arena for the artist's free actions, which the spectator relives through the traces they leave. Art is no longer mediation but act. No longer pursuit but arrival.

What we are slowly making our way towards are the pictorial consequences of Rosenberg's *nothingness* and the fatality.

a kind of sharing

PHOTOS OF LEE KRASNER and Jackson Pollock together somehow indicate how much theirs was a marriage of two painters. It's on their clothes. You can smell the paint. Lee Krasner's first love was a Russian painter called Igor Pantuhoff. She lived with him for eleven years. When she first met Pollock, she was thirty-four and better known as an artist than he was. "I had a comet by the tail," she said afterwards. What called out to her was, surely, what she felt to be Pollock's destiny as an artist. He was inspired, probably more inspired than anybody she had ever met. And for Jackson Pollock the champion, always fearful of losing, Lee was at last the judge he could trust. If she told him that something he had painted worked, he believed it—at least at the beginning of their marriage. Between them the ultimate in praise was "It works." A phrase between professionals.

From 1943 till 1952—the period when Pollock produced all his most surprising work—the two of them were, in part, painting for each other: to see each other's surprise. It was a way of communicating, of touching or being touched. (Maybe there were not many ways of communicating with Pollock.) During these years Lee Krasner painted less than she did before or afterwards. Pollock took the studio on the property they bought in Springs, and she worked in a bedroom. Yet the arguement that she sacrificed her art for his is as stupid as the argument about who influenced whom. (In 1953 Pollock produced a canvas called *Easter and the Totem* which anybody might mistake for a Krasner.) The truth is that as painters and as a man and a woman, they were engaged, during these years, in the same adventure which turned out to be more fatal than either of them realized at the time. And today their canvases speak of it.

Lee Krasner's paintings were, by nature, sensuous and ordered. Their colours and gestures frequently suggested flesh, the body; their order, a garden. Abstract as they are, one enters them to find, behind the colours or collage, a kind of welcome.

By contrast, Pollock's paintings were metaphysical in aim and violent. The body, the flesh, had been rejected and they were the consequence of this rejection. One can feel the painter, at first with gestures that are almost childish, and later like a strong, fully grown man, emptying his body of energy and liquids so as to leave traces to prove that he had physically existed. On one occasion he put his hand prints on the painting as if beseeching the canvas to acknowledge the exiled body. There is an order in these works, but it is like that at the centre of an explosion, and all over their surfaces there is a terrible indifference to everything that is sentient.

When their paintings are hung together, the dialogue between them is very clear. He paints an explosion; she, using almost identical pictorial elements, constructs a kind of consolation. (Perhaps their paintings said things to one another during these years that they could never say in person.) Yet it would be wrong to give the impression that Krasner's paintings were primarily consolatory. Between the two of them there was a fundamental issue at stake. Time and again her paintings demonstrated an alternative to the brink which they sensed his were heading for. Time and again her paintings protested against the art's threat of suicide. And I think they did this as paintings whilst Lee Krasner as a person was being dazzled by the brilliance of his recklessness.

An obvious example would be a painting called *Bald Eagle*, made in 1955, one year before the car accident. Here Lee Krasner took a canvas Jackson Pollock had abandoned—a bare hessian canvas with flicked black lines across it—and incor-

porated pieces of this canvas into a large colourful collage, a little suggestive of autumn and a bird soaring. Thus her picture saved the lost gestures of his. The example, however, is not typical, for it occurred after the suicide.

Before, he would splatter, and she would take the same pigment, the same colours, and assemble. He would thrash; and she would make the same wound and stitch it. He would paint flames; and she would paint fire in a brazier. He would throw paint imitating a comet; and she would paint a part of the Milky Way. Every time the pictorial elements—as distinct from the purpose—were similar, if not almost identical. He would lend himself to a deluge; she would imagine water gushing into a basin.

But the messages of her paintings to his paintings were not about domestication. They were about continuity, they were about the desire of painting to go on living.

Unfortunately, it was already too late.

POLLOCK HAD STOOD the art of painting on its head, reversed it, negated it.

The negation had nothing to do with technique or abstraction. It was inherant in his purpose—in the *will* which his canvases expressed.

On these canvases the visible is no longer an opening but something which has been abandoned and left behind. The drama depicted is something that once happened *in front of* the canvas—where the painter claimed to be nature! Within or beyond them there is nothing. Only the visual equivalent of total silence.

Painting throughout its history has served many different purposes, has been flat and has used perspective, has been framed and has been left borderless, has been explicit and

has been mysterious. But one act of faith has remained a constant from palaeolithic times to cubism, from Tintoretto (who also loved comets) to Rothko. The act of faith consisted of believing that the visible contained hidden secrets, that to study the visible was to learn something more than could be seen in a glance. Thus paintings were there to reveal a presence *behind* an appearance—be it that of a Madonna, a tree or, simply, the light that soaks through a red.

Jackson Pollock was driven by a despair which was partly his and partly that of the times which nourished him, to refuse this act of faith: to insist, with all his brilliance as a painter, that there was nothing behind, that there was only *that which was done to the canvas on the side facing us*. This simple, terrible reversal, born of an individualism which was frenetic, constituted the suicide.

CHRIST OF THE PEASANTS

I TRY TO IMAGINE how to describe the pilgrim photographs of Marketa Luskacova to somebody who could not see them. An obviously vain exercise in one sense, because appearances and words speak so differently; the visual never allows itself to be translated intact into the verbal. Nothing I could say would enable the reader to imagine a single one of these pictures. Yet what of those who, finding themselves before the photographs, still have difficulty in seeing them? There are good reasons why this might happen. The pictures are of peasants whose experience over the centuries has been very rarely understood by other classes. Worse than that, the pictures are about the experience of religious faith when today most city-dwellers—at least in our continent—have become accustomed to living without any religious belief. Finally, even for the religious minority the pictures may well suggest fanaticism or heresy, because priests and the Church have for so long oppressed peasants, and this oppression has encouraged on both sides the recurring suspicion that principles are being betrayed. The Christ of the peasants has never been the Christ of the papacy. How, then, would I describe the photographs to somebody who could not see them?

I'm inclined to believe that Marketa Luskacova had a secret assignment, such as no photographer had had before. She was summoned by the Dead. How she joined them I don't know. The Dead live, of course, beyond time and are ageless; yet, thanks to the constant arrival of newcomers, they are

aware of what happens in history, and sometimes this general, vast awareness of theirs provokes a kind of curiosity so that they want to know more. This curiosity led them to summon a photographer. They told her how they had the impression— and it had been growing for a century or more—that they, the Dead, were being forgotten by the Living to an unprecedented degree. Let her understand clearly what they were talking about: the individual Dead had always been quickly or slowly forgotten—it was not this which was new. But now it appeared that the huge, in fact countless, collective of the Dead was being forgotten, as if the living had become—was it ashamed? or was it simply negligent?—of their own mortality, of the very consanguinity which joined them to the Dead. Of this, they said they needed no proof, there was ample evidence. What they would like to see—supposing that somewhere in the heart of the continent in which she lived they still existed—were people who still remembered the Dead. Neither the bereaved (for bereavement is temporary) nor the morbid (for they are obsessed by death, not by the Dead), but people living their everyday lives whilst looking further, beyond, aware of the Dead as neighbors.

"We would like you," they told her, "to do a reportage on *us*, in the eyes of the living: can you do that?" She did not reply, for she already knew, although she was only in her early twenties, that the only possible reply could be in the images developed in a dark-room.

Soon after, Luskacova found herself in the village of Sumiac. Before beginning her assignment proper, she took some pictures to remind the long-departed of the earth on which everything happens. A woman and a horse, with the grass cropped and the footpaths going as far back as living memory. A man sowing, striding slowly through the field he has ploughed, the gesture of his arm like that of a cellist. Three children asleep in a bed.

Then she moved on to the unprecedented challenge of

her commission. The people she was photographing trusted her; more than that, they allowed her to become intimate. This was a precondition for her assignment, for she could not photograph the presence of the Dead in the lives of the living from afar: a telescopic lens in this case would have been useless. Nor could she be in a hurry. Intimacy implies having time on one's hands, even a kind of boredom. And further, she could not be in a hurry because the project demanded isolating an instant filled with the timeless, and isolating a set of appearances containing the invisible. These were not impossible demands, since the human eye and the human face are windows on to the soul.

In some pictures she failed—failed for a simple and understandable reason. Sometimes the people being photographed were aware of her being there with her camera, they trusted her completely and so they appealed for recognition. In a flash they imagined how: *Take Us Now = We'll See How We Were at This Moment.*

In other pictures she succeeded; she carried out the assignment and she produced photos such as nobody had ever taken before. We see the photographed in all their intimacy and they are not *there*; they are *elsewhere* with their neighbors: the dead, the unborn, the absent. For instance, her extraordinary photo of the Sleeping Man might be a companion piece to a poem by Rilke:

> . . . You, neighbor God, if sometimes in the night
> I rouse you with loud knocking, I do so
> only because I seldom hear you breathe
> and know: you are alone.
> And should you need a drink, no one is there
> to reach it to you, groping in the dark.
> Always I hearken. Give but a small sign.
> I am quite near.

Between us there is but a narrow wall,
and by sheer chance; for it would take
merely a call from your lips or from mine
to break it down,
and that without a sound.

The wall is builded of your images . . .

To stop there would be too resolved, too "transcendental" for the peasant experience which Marketa Luskacova interprets so faithfully. The peasant, within the secrecy of his own mind, is independent, and he projects this independence on to those he worships. *Nothing is ever quite arranged.*

Italo Calvino has recorded a story from the countryside near Verona; and I think of it when, for instance, I look at the picture of the builders at Sumiac eating a meal:

Once there was a farmer who was devout, but who prayed only to St. Joseph. When he died, St. Peter refused to let him into heaven. "No question," said St. Peter, "you forgot about Christ, God the Father and the Virgin." "Since I'm here," replied the man, "could I have a word with Joseph?" Joseph appeared, recognized the farmer and said: "Come in, make yourself at home." "I can't," complained the man, "Peter here has forbidden me to enter heaven." Joseph turned to Peter and angrily remonstrated: "You let him in here, or I'll take my son and my wife and we'll go somewhere else to build paradise!"

"THE VISIBLE."

A PROFESSIONAL SECRET

"WHEN SOMEBODY IS DEAD, you can see it from two hundred yards away," says Goya in a play we wrote, "his silhouette goes cold".

I wanted to see Holbein's painting of the dead Christ. He painted it in 1552 when he was twenty-five. It is long and thin—like a slab in a morgue, or like the predella of an altarpiece—although it seems that this painting never joined an altarpiece. There is a legend that Holbein painted it from the corpse of a Jew drowned in the Rhine.

I'd heard and read about the picture. Not least from Prince Myshkin in *The Idiot*. "That painting!" he exclaimed. "That painting! Do you realize what it could do? It could make a believer lose his faith."

Dostoevsky must have been as impressed as Prince Myshkin, for he makes Hypolyte, another character in *The Idiot*, say: "Supposing on the day before his agony the Lord had seen this picture, would he have been able to go to his crucifixion and death as he did?"

Holbein painted an image of death, without any sign of redemption. Yet what exactly is its effect?

Mutilation is a recurrent theme in Christian iconography. The lives of the martyrs, St. Catherine, St. Sebastian, John the Baptist, the Crucifixion, the Last Judgement. Murder and rape are common subjects in painted classical mythology.

Before Pollaiuolo's *St. Sebastian*, instead of being horrified

(or convinced) by his wounds, one is seduced by the naked limbs of both executioners and executed. Before Rubens's *Rape of the Daughters of Leucippus*, one thinks of nights of exchanged love. Yet this sleight-of-hand by which one set of appearances replaces another (the martyrdom becomes an Olympics: the rape becomes a seduction) is nevertheless an acknowledgement of an original dilemma: how can the brutal be made visibly acceptable?

The question begins with the Renaissance. In medieval art the suffering of the body was subservient to the life of the soul. And this was an article of faith which the spectator brought with him to the image; the life of the soul did not have to be demonstrated in the image itself. A lot of medieval art is grotesque—that is to say a reminder of the worthlessness of everything physical. Renaissance art idealizes the body and reduces brutality to gesture. (A similar reduction occurs in Westerns: see John Wayne or Gary Cooper.) Images of consequential *brutality* (Breughel, Grünewald, etc.) were marginal to the Renaissance tradition of harmonizing dragons, executions, cruelty, massacres.

At the beginning of the nineteenth century Goya, because of his unflinching approach to horror and brutality, was the first modern artist. Yet those who choose to look at his etchings would never choose to look at the mutilated corpses they depict with such fidelity. So we are forced back to the same question, which one might formulate differently: how does catharsis work in visual art, if it does?

Painting is distinct from the other arts. Music by its nature transcends the particular and the material. In the theatre words redeem acts. Poetry speaks to the wound but not to the torturers. Yet the silent transaction of painting is with appearances and it is rare that the dead, the hurt, the defeated, or the tortured *look* either beautiful or noble.

A painting can be pitiful?

How is pity made visible?

Perhaps it's born in the spectator in face of the picture?

Why does one work produce pity when another does not? I don't believe pity comes into it. A lamb chop painted by Goya touches more pity than a massacre by Delacroix.

So, how does catharsis work?

It doesn't. Paintings don't offer catharsis. They offer something else, similar but different.

What?

I don't know. That's why I want to see the Holbein.

WE THOUGHT THE HOLBEIN was in Berne. The evening we arrived we discovered it was in Basel. Because we had just crossed the Alps on a motorbike, the extra hundred kilo-metres seemed too far. The following morning we visited instead the museum in Berne.

It is a quiet, well-lit gallery rather like a space vessel in a film by Kubrick or Tarkovsky. Visitors are asked to pin their entrance tickets on to their lapels. We wandered from room to room. A Courbet of three trout, 1873. A Monet of ice breaking up on a river, 1882. An early cubist Braque of houses in L'Estaque, 1908. A love song with a new moon by Paul Klee, 1939. A Rothko, 1963.

How much courage and energy were necessary to struggle for the right to paint in different ways! And today these can-vases, outcome of that struggle, hang peacefully beside the most conservative pictures: all united within the agreeable aroma of coffee, wafted from the cafeteria next to the book shop.

The battles were fought over what? At its simplest—over the language of painting. No painting is possible without a pictorial language, yet with the birth of modernism after the

French Revolution, the use of any language was always controversial. The battles were between custodians and innovators. The custodians belonged to institutions that had behind them a ruling class or an élite who needed appearances to be rendered in a way which sustained the ideological basis of their power.

The innovators were rebels. Two axioms to bear in mind here: sedition is, by definition, ungrammatical; the artist is the first to recognize when a language is lying. I was drinking my second cup of coffee and still wondering about the Holbein, a hundred kilometres away.

Hypolyte in *The Idiot* goes on to say: "When you look at this painting, you picture nature as a monster, dumb and implacable. Or rather—and however unexpected the comparison may be it is closer to the truth, much closer—you picture nature as an enormous modern machine, unfeeling, dumb, which snatched, crushed and swallowed up a great Being, a Being beyond price, who, alone, is worth the whole of nature. . . ."

Did the Holbein so shock Dostoevsky because it was the opposite of an ikon? The ikon redeems by the prayers it encourages with closed eyes. Is it possible that the courage to not shut one's eyes can offer another kind of redemption?

I FOUND MYSELF before a landscape painted at the beginning of the century by an artist called Caroline Müller—*Alpine Chalets at Sulward near Isenflushul*. The problem about painting mountains is always the same. The technique is dwarfed (like we all are) by the mountain, so the mountain doesn't live; it's just there, like the tombstone of a distant grey or white ancestor. The only European exceptions I know are Turner, David Bomberg and the contemporary Berlin painter Werner Schmidt.

In Caroline Müller's rather dull canvas three small apple trees made me take in my breath. *They* had been seen. Their having-been-seen could be felt across eighty years. In that little bit of the picture the pictorial language the painter was using ceased to be just accomplished and became urgent.

Any language as taught always has a tendency to close, to lose its original signifying power. When this happens it can go straight to the cultivated mind, but it bypasses the thereness of things and events.

"Words, words, mere words, no matter from the heart."

Without a pictorial language, nobody can render what they see. With one, they may stop seeing. Such is the odd dialectic of the practice of painting or drawing appearances since art began.

We came to an immense room with fifty canvases by Ferdinand Hodler. A gigantic life's work. Yet in only one of the paintings had he forgotten his accomplishment and could we forget that we were looking at virtuoso pigment. It was a relatively small picture and it showed the painter's friend, Augustine Dupin, dying in her bed. Augustine was seen. The language, in being used, had opened.

WAS THE JEW who drowned in the Rhine seen in this sense by the twenty-five-year-old Holbein? And what might this being-seen mean?

I returned to look at the paintings I'd studied earlier. In the Courbet of the three fish, hanging gaffed from a branch, a strange light permeates their plumpness and their wet skins. It has nothing to do with glistening. It is not on the surface but comes through it. A similar but not identical light (it's more granular) is also transmitted through the pebbles on the river's edge. This light-energy is the true subject of the painting.

In the Monet the ice on the river is beginning to break up. Between the jagged opaque pieces of ice there is water. In this water (but not of course on the ice) Monet could see the still reflections of the poplars on the far bank. And these reflections, glimpsed *behind* the ice, are the heart of the painting.

In the Braque of L'Estaque, the cubes and triangles of the houses and the V forms of the trees are not imposed upon what his eye saw (as happens later with the mannerists of cubism), but somehow drawn from it, brought forward from behind, salvaged from where the appearances had begun to come into being and had not yet achieved their full particularity.

In the Rothko the same movement is even clearer. His life's ambition was to reduce the substance of the apparent to a pellicle thinness, aglow with what lay behind. Behind the grey rectangle lies mother-of-pearl, behind the narrow brown one, the iodine of the sea. Both oceanic.

Rothko was a consciously religious painter. Yet Courbet was not. If one thinks of appearances as a frontier, one might say that painters search for messages which cross the frontier: messages which come from the back of the visible. And this, not because all painters are Platonists, but because they look so hard.

Image-making begins with interrogating appearances and making marks. Every artist discovers that drawing—when it is an urgent activity—is a two-way process. To draw is not only to measure and put down, it is also to receive. When the intensity of looking reaches a certain degree, one becomes aware of an equally intense energy coming towards one, through the appearance of whatever it is one is scrutinizing. Giacometti's life's work is a demonstration of this.

The encounter of these two energies, their dialogue, does not have the form of question and answer. It is a ferocious

and inarticulated dialogue. To sustain it requires faith. It is like a burrowing in the dark, a burrowing under the apparent. The great images occur when the two tunnels meet and join perfectly. Sometimes when the dialogue is swift, almost instantaneous, it is like something thrown and caught.

I offer no explanation for this experience. I simply believe very few artists will deny it. It's a professional secret.

The act of painting—when its language opens—is a response to an energy which is experienced as coming from behind the given set of appearances. What is this energy? Might one call it the will of the visible that sight should exist? Meister Eckardt talked about the same reciprocity when he wrote: "The eye with which I see God is the same eye with which he sees me." It is the symmetry of the energies which offers us a clue here, not the theology.

Every real act of painting is the result of submitting to that will, so that in the painted version the visible is not just interpreted but allowed to take its place actively in the community of the painted. Every event which has been really painted—so that the pictorial language opens—joins the community of everything else that has been painted. Potatoes on a plate join the community of a loved woman, a mountain, or a man on a cross. This—and this only—is the redemption which painting offers. This mystery is the nearest painting can offer to catharsis.

ONE BEAR

PHOTO OF BEAR BY JEAN MOHR.

132

THE BEAR WAS in a room, a large room with links with the past, as all rooms which are really living must have.

The bear was a little larger than I and he lived in this room. He belonged there. Perhaps sometimes he was elsewhere, but this was where he lived. I was a guest in the house and in the room.

The bear was chained to the wall by a long chain. Apparently, he did not suffer by this curtailment. He was as much a part of the room as the fire in the grate, or the table by the wall with the mirror above it. But he was alive. That is important. Although he was chained to the wall, he was like the host of that room. The last thing a visitor could feel was pity for him.

I was conversing with him. Not with words. If I spoke, he understood what I said. But to converse with him it was necessary to act. I was playing with him, wrestling.

He was a bear. He had a tail, a long bushy tail as no bear has. Nevertheless, I will call him a bear. And I'll say *he*. Though it might just as well be *she*. Perhaps no pronoun is required. I can always say *Bear*.

We were wrestling. Neither Bear nor I showed any signs of fear or hostility. Claws withdrawn. At that time it did not occur to me that I could be clawed.

We wrestled and pushed each other around. I can still feel Bear's paw, the skin of it, like cooked carp skin, but

coarser. And I can see eyes: very dark and opaque. Hiding any expression. It was our wrestling dance that was full of expression. To wrestle is to dance with a Bear. And in the well-furnished room in the house which was otherwise silent but not oppressively so, we danced. Bear and I.

Then I noticed something. The chain to the wall was broken. Bear had not realized it. I continued to dance. It was a question of honour. I foresaw the dangers. I thought of disengaging myself and leaving. But I couldn't. Frightened as I was, there was a law stronger than my fear. It was not for me to react first to the chain being broken. It was not my chain. And Bear danced the same as before. Bear was still like the fire, a welcome prisoner in the room.

The end of the chain, which had been fixed to an iron ring in the wall, lay on the ground. My eyes kept on coming back to it as we conversed in wider and wider circles. And although I was still very frightened, I felt something else too. Bear, who had been led on a chain during a century or more from village to village, because Bear stood on two legs and not four, because bear fur was warm and smelt sweet, because Bear had dark intelligent eyes and slow movements, because Bear reminded some men of a man, this bear, at last, by breaking the chain, was free.

In every liberation, whatever happens later, there is a beauty. This beauty has a kind of abandon to it. Bear was dancing with more and more abandon. I had been mistaken. Bear knew. Perhaps had known from the beginning.

The beauty was in the knowing as well as in the heavy abandoned swaying from leg to leg. I thought, Now I can go; my reaction to the broken chain will not be the first. Still wrestling, still dancing, I steered us towards the door. Previously, I had assumed Bear was not aware of the new freedom; now I assumed Bear would not notice my cunning. For the second time I was wrong.

With one hand I felt behind my back for the door handle. I would be far quicker through the door than Bear. I would lock it and leave the house.

Immediately, I saw Bear with a knife. A knife? Or an extended claw? A blade like a scimitar, curved but very short. Grey-yellow in colour. First one and then several.

The paw was held at my throat, the point of each blade against my skin. I pressed the muzzle of a gun into the bear's stomach. We waited, the two of us.

Then I said: Let us fight without weapons.

Bear threw five knives on the floor. I threw the gun. Before the clatter of these weapons hitting the floor had died away, I was out through the door. I locked it and ran, just as I had planned. Bear, I hoped, was a prisoner again.

During my encounter with the bear, the house had moved, the house and the whole village with it. I turned down a flight of steps off the main street and at the bottom, instead of a road of plane trees, I found the sea. Waves were breaking gently against the walls of the village.

Have I already told you it was night? It was night when I first began conversing with the bear. The sea looked very black except for the spray of the waves. And it was cold. Winter cold. The weather of the bear.

I climbed up the steps and took a passage which led off from the other side of the main street. Again, at the bottom, I came to the sea. During my conversation with the bear, the village had become an island. There was no further question of escape.

Under an empty arcade I went into a café and ordered a hot drink. Nobody in the café looked concerned. The windows were steamed up. I passed between men drinking and clinking glasses. The place had the air of the end of a celebration. All the men were peasants from the village. They knew me— although they considered me a stranger. I could see in none

of them a trace of surprise at the fact that their village, so far from the sea, had overnight become an island.

I knew now that the bear would soon be out, at liberty. One locked door would not succeed where a chain and the usage of a century had failed. The bear would find me behind the steamed-up windows.

I left the café and walked along the first path by the sea's edge. When I looked up to the top of the flight of steps, I saw Bear, descending slowly, wearing clothes. This time no cunning could save me.

Yet in the figure of Bear wearing clothes, coming down the steps in the dark and cold, there was still something of the abandon of the moment of liberation. And I felt a pleasure in that, apart from my fear. This pleasure was like the smallest bird in the world—the bee humming-bird—singing underneath the largest cataract.

From my pocket I drew out a book and went to where the only streetlamp was attached to the wall of the village, and there began to read.

The book told the story of Bear and myself. Hurriedly, I turned to the last page to see what was still to happen.

I walked across to the steps. The bear was half-way down. I began to climb up towards the bear. The animal made no sign. We were near to each other now, but despite Bear's immense weight, each foot descended to the next step without making a sound. I thought then, whilst ascending and waiting for our meeting, that in that soundlessness we might find a peace.

In the book it said that the bear had forgiven.

APE THEATRE

[*In memory of Peter Fuller and our many conversations about the chain of being and Neo-Darwinism*]

PHOTO OF ORANG-UTAN BY JEAN MOHR.

IN BASEL the zoo is almost next to the railway station. Most of the larger birds in the zoo are free-flying, and so it can happen that you see a stork or a cormorant flying home over the marshalling yards. Equally unexpected is the ape house. It is constructed like a circular theatre with three stages: one for the gorillas, another for the orang-utans and a third for the chimpanzees.

You take your place on one of the tiers—as in a Greek theatre—or you can go to the very front of the pit, and press your forehead against the soundproof plate glass. The lack of sound makes the spectacle on the other side, in a certain way, sharper, like mime. It also allows the apes to be less bothered by the public. We are mute to them too.

ALL MY LIFE I've visited zoos, perhaps because going to the zoo is one of my few happy childhood memories. My father used to take me. We didn't talk much, but we shared each other's pleasure, and I was well aware that his was largely based on mine. We used to watch the apes together, losing all sense of time, each of us, in his fashion, pondering the mystery of progeniture. My mother, on the rare occasions she came with us, refused the higher primates. She preferred the newly found pandas.

I tried to persuade her, but she would reply, following

ape theatre

her own logic: "I'm a vegetarian and I only gave it up, the practice not the principle, for the sake of you boys and for Daddy." Bears were another animal she liked. Apes, I can see now, reminded her of the passions which lead to the spilling of blood.

THE AUDIENCE IN BASEL is of all ages. From toddlers to pensioners. No other spectacle in the world can attract such a wide spectrum of the public. Some sit, like my father and I once did, lost to the passing of time. Others drop in for a few moments. There are habitués who come every day and whom the actors recognize. But on nobody—not even the youngest toddler—is the dramatic evolutionary riddle lost: how is it that they are so like us and yet not us?

This is the question which dominates the dramas on each of the three stages. Today the gorillas' play is a social one about coming to terms with imprisonment. Life sentences. The chimpanzees' is cabaret, for each performer has her or his own number. The orang-utans' is *Werther* without words—soulful and dreamy. I am exaggerating? Of course, because I do not yet know how to define the real drama of the theatre in Basel.

Is theatre possible without an awareness of re-enactment, which is related to a sense of death? Probably not. But perhaps both, almost, exist here.

Each stage has at least one private recess where an animal can go if she or he wishes to leave the public. From time to time they do so. Sometimes for quite long periods. When they come out to face the audience again, they are perhaps not so far from a practice of re-enactment. In the London zoo chimps pretended to eat and drink off invisible plates with non-existent glasses. A pantomime.

141

As for a sense of death, chimpanzees are as familiar as we are with fear, and the Dutch zoologist Dr. Kortlaudt believes they have intimations of mortality.

In the first half of the century there were attempts to teach chimpanzees to talk—until it was discovered that the form of their vocal tract was unsuitable for the production of the necessary range of sounds. Later they were taught a deaf and dumb language, and a chimp called Washoe in Ellensburg, Washington, called a duck a water bird. Did this mean that Washoe had broken through a language barrier, or had she just learnt by rote? A heated debate followed (the distinction of man was at stake!) about what does or does not constitute a language for animals.

It was already known—thanks to the extraordinary work of Jane Goodall, who lived with her chimpanzees in the wild in Tanzania—that these animals used tools, and that, language or no language, their ability to communicate with one another was both wide-ranging and subtle.

Another chimpanzee in the United States named Sarah, underwent a series of tests, conducted by Douglas Gillan, which were designed to show whether or not she could reason. Contrary to what Descartes believed, a verbal language may not be indispensable for the process of reasoning. Sarah was shown a video of her trainer playing the part of being locked in a cage and desperately trying to get out! After the film she was offered a series of pictures of varying objects to choose from. One, for instance, showed a lighted match. The picture she chose was of a key—the only object which would have been useful for the situation she had seen enacted on the video screen.

IN BASEL we are watching a strange theatre in which, on both sides of the glass, the performers may believe they are an audience. On both sides the drama begins with resemblance and the uneasy relationship that exists between resemblance and closeness.

The idea of evolution is very old. Hunters believed that animals—and especially the ones they hunted—were in some mysterious way their brothers. Aristotle argued that all the forms of nature constituted a series, a chain of being, which began with the simple and became more and more complex, striving towards the perfect. In Latin *evolution* means unfolding.

A group of handicapped patients from a local institution come into the theatre. Some have to be helped up the tiers, others manage by themselves, one or two are in wheelchairs. They form a different kind of audience—or rather, an audience with different reactions. They are less puzzled, less astounded, but more amused. Like children? Not at all. They are less puzzled because they are more familiar with what is out of the ordinary. Or, to put it another way, their sense of the norm is far wider.

What was new and outrageous in *The Origin of Species* when it was first published in 1859 was Darwin's argument that all animal species had evolved from the same prototype, and that this immensely slow evolution had taken place through certain accidental mutations being favoured by natural selection, which had worked according to the principle of the survival of the fittest. A series of accidents. Without design or purpose and without experience counting. (Darwin rejected Lamarck's thesis that acquired characteristics could be inherited.) The pre-condition for Dar-

win's theory being plausible was something even more shocking: the wastes of empty time required: about 500 million years!

Until the nineteenth century it was generally, if not universally, believed that the world was a few thousand years old—something that could be measured by the time scale of human generations. (As in Genesis, chapter 5.) But in 1830 Charles Lyell published *The Principles of Geology* and proposed that the earth, with "no vestige of a beginning—no prospect of an end," was millions, perhaps hundreds of millions of years old.

Darwin's thinking was a creative response to the terrifying immensity of what had just been opened up. And the sadness of Darwinism—for no other scientific revolution, when it was made, broadcast so little hope—derived, I think, from the desolation of the distances involved.

The sadness, the desolation, is there in the last sentence of *The Descent of Man*, published in 1871: "We must, however, acknowledge, as it seems to me, that man with all his noble qualities, still bears in his bodily frame the indelible stamp of his lowly origin."

"The indelible stamp" speaks volumes. "Indelible" in the sense that (unfortunately) it cannot be washed out. "Stamp" meaning "brand, mark, stain." And in the word "lowly" during the nineteenth century, as in Thatcher's Britain, there is shame.

The liberty of the newly opened-up space-time of the universe brought with it a feeling of insignificance and *pudeur*, from which the best that could be redeemed was the virtue of intellectual courage, the virtue of being unflinching. And courageous the thinkers of that time were!

ape theatre

Whenever an actor, who is not a baby wants to piss or shit, he or she gets up and goes to the edge of a balcony or deck, and there defecates or urinates below, so as to remain clean. An habitual act which we seldom see enacted on the stage. And the effect is surprising. The public watch with a kind of pride. An altogether legitimate one. Don't shit yourself. Soon we'll be entering another century.

Mostly, the thinkers of the nineteenth century thought mechanically, for theirs was the century of machines. They thought in terms of chains, branches, lines, comparative anatomies, clockworks, grids. They knew about power, resistance, speed, competition. Consequently, they discovered a great deal about the material world, about tools and production. What they knew less about is what we still don't know much about: the way brains work. I can't get this out of my mind: it's somewhere at the centre of the theatre we're watching.

Apes don't live entirely within the needs and impulses of their own bodies—like the cats do. (It may be different in the wild, but this is true on the stage.) They have a gratuitous curiosity. All animals play, but the others play at being themselves, whereas the apes experiment. They suffer from a surplus of curiosity. They can momentarily forget their needs, or any single unchanging role. A young female will pretend to be a mother cuddling a baby lent by its real mother. "Babysitting," the zoologists call it.

Their surplus of curiosity, their research (every animal searches, only apes research) make them suffer in two evident ways—and probably also in others, invisibly. Their bodies, forgotten, suddenly nag, twinge, and irritate. They become impatient with their own skin—like Marat suffering from eczema.

And then too, starved of events, they suffer boredom. Baudelaire's *l'ennui*. Not at the same level of self-doubt, but nevertheless with pain, apathy. The signs of boredom may

145

resemble those of simple drowsiness. But *l'ennui* has its unmistakable lassitude. The body, instead of relaxing, huddles, the eyes stare painfully without focus, the hands, finding nothing new to touch or do, become like gloves worn by a creature drowning.

"If it could be demonstrated," Darwin wrote, "that any complex organ existed which could not possibly have been formed by numerous, successive slight modifications, my theory would absolutely break down."

If the apes are partly victims of their own bodies—the price they pay, like man, for not being confined to their immediate needs—they have found a consolation, which Europe has forgotten. My mother used to say the chimps were looking for fleas, and that when they found one, they put it between their teeth and bit it. But it goes further than Mother thought—as I guessed even then. The chimpanzees touch and caress and scratch each other for hours on end (and according to the etiquette rules of a strict group hierarchy) not only hygienically, to catch parasites, but to give pleasure. "Grooming," as it is called, is one of their principal ways of appeasing the troublesome body.

This one is scratching inside her ear with her little finger. Now she has stopped scratching to examine minutely her small nail. Her gestures are intimately familiar and strikingly remote. (The same is true for most actions on any theatre stage.) An orang-utan is preparing a bed for herself. Suddenly, she hesitates before placing her armful of straw on the floor, as if she has heard a siren. Not only are the apes' functional gestures familiar, but also their expressive ones. Gestures which denote surprise, amusement, tenderness, irritation, pleasure, indifference, desire, fear.

ape theatre

But they move differently. A male gorilla is sitting at ease with his arm held straight and high above his head; and for him this position is as relaxed as sitting with legs crossed is for women and men. Everything which derives from the apes' skill in swinging from branches—*brachiation*, as the zoologists call it—sets them apart. Tarzan only swung from vines—he never used his hanging arms like legs, walking sideways.

In evolutionary history, however, this difference is in fact a link. Monkeys walk on all fours along the tops of branches and use their tails for hanging. The common ancestors of man and apes began, instead, to use their arms—began to become *brachiators*. This, the theory goes, gave them the advantage of being able to reach fruit at the ends of branches!

I must have been two years old when I had my first cuddly toy. It was a monkey. A chimpanzee, in fact. I think I called him Jackie. To be certain, I'd have to ask my mother. She would remember. But my mother is dead. There is just a chance—one in a hundred million (about the same as a chance mutation being favoured by natural selection) that a reader may be able to tell me, for we had visitors to our home in Higham's Park, in East London, sixty years ago, and I presented my chimp to everyone who came through the front door. I think his name was Jackie.

Slowly, the hanging position, favoured by natural selection, changed the anatomy of the brachiator's torsos so that finally they became half-upright animals—although not yet as upright as humans. It is thanks to hanging from trees that we have long collarbones which keep our arms away from our chests, wrists which allow our hands to bend backwards and sideways, and shoulder sockets that let our arms rotate.

It is thanks to hanging from trees that one of the actors can throw himself into the arms of a mother and cry. Brachiation gave us breasts to beat and to be held against. No other animal can do these things.

WHEN DARWIN THOUGHT about the eyes of mammals, he admitted that he broke out in a cold sweat. The complexity of the eye was hard to explain within the logic of his theory, for it implied the co-ordination of so many evolutionary "accidents." If the eye is to work at all, all the elements have to be there: tear glands, eyelid, cornea, pupil, retina, millions of light-sensitive rods and cones which transmit to the brain millions of electrical impulses per second. Before they constituted an eye, these intricate parts would have been useless, so why should they have been favoured by natural selection? The existence of the eye perfidiously suggests an evolutionary aim, an intention.

Darwin finally got over the problem by going back to the existence of light-sensitive spots on one-celled organisms. These, he claimed, could have been "the first eye" from which the evolution of our complex eyes first began.

I have the impression that the oldest gorilla may be blind. Like Beckett's Pozzo. I ask his keeper, a young woman with fair hair. Yes, she says, he's almost blind. How old is he? I ask. She looks at me hard. About your age, she replies, in his early sixties.

Recently, molecular biologists have shown that we share with apes 99 percent of their DNA. Only 1 percent of his genetic code separates man from the chimpanzee or the gorilla. The orang-utan, which means in the language of the people of Borneo "man of the forest," is fractionally further removed. If we take another animal family, in order to emphasize how small the 1 percent is, a dog differs from a raccoon by 12 percent. The genetic closeness between man and ape—apart from making our theatre possible—strongly suggests that their common ancestor existed not 20 million years ago

as the Neo-Darwinist palaeontologists believed, but maybe only 4 million years ago. This molecular evidence has been contested because there are no fossil proofs to support it. But in evolutionary theory fossils, it seems to me, have usually been notable by their absence!

In the Anglo-Saxon world today the Creationists, who take the Genesis story of the Creation as the literal truth, are increasingly vocal and insist that their version be taught in schools alongside the Neo-Darwinist one. The orang-utan is like he is, say the Creationists, because that's the way God made him, once and for all, five thousand years ago! He is like he is, reply the Neo-Darwinists, because he has been efficient in the ceaseless struggle for survival!

Her orang-utan eyes operate exactly like mine—each retina with its 130 million rods and cones. But her expression is the oldest I've ever seen. Approach it at your peril, for you can fall into a kind of maelstrom of ageing. The plunge is still there in Jean Mohr's photo.

NOT FAR UP THE RHINE from Basel, Angelus Silesius, the seventeenth-century German doctor of medicine, studied in Strasbourg, and he once wrote:

> Anybody who passes more than a day in eternity
> is as old as God could ever be.

I look at her with her eyelids which are so pale that when she closes them they're like eyecups, and I wonder.

Certain Neo-Darwinist ideas are intriguing: Bolk's theory of neoteny, for instance. According to Bolk, "man in his bodily development is a primate foetus that has become sexually mature," and consequently can reproduce. His theory pro-

poses that a genetic code can stop one kind of growth and encourage another. Man is a neonate ape to whom this happened. Unfinished, he is able to learn more.

It has even been argued that today's apes may be descendants of a hominid, and that in them the neoteny brake was taken off so that they stopped stopping at the foetus stage, grew body hair again and were born with tough skulls! This would make them more modern than we are.

Yet in general, the conceptual framework in which the Neo-Darwinists and the creationists debate, is of such limited imagination that the contrast with the immensity of the process whose origin they are searching is flagrant. They are like two bands of seven-year-olds who, having discovered a packet of love letters in an attic, try to piece together the story behind the correspondence. Both bands are ingenious and argue ferociously with one another, but the passion of the letters is beyond their competence.

Perhaps it is objectively true that only poetry can talk of birth and origin. Because true poetry invokes the whole of language (it breathes with everything it has not said), just as the origin invokes the whole of life, the whole of Being.

The mother orang-utan has come back, this time with her baby. She is sitting right up against the glass. The children in the audience have come close to watch her. Suddenly, I think of a Madonna and Child by Cosimo Tura. I'm not indulging in a sentimental confusion. I haven't forgotten I'm talking about apes any more than I've forgotten I'm watching a theatre. The more one emphasizes the millions of years, the more extraordinary the expressive gestures become. Arms, fingers, eyes, always eyes. . . . A certain way of being protective, a certain gentleness—if one could feel the fingers on one's neck, one would say a certain *tenderness*—which has endured for five million years.

A species that did not protect its young would not survive,

comes the answer. Indisputably. But the answer does not explain the theatre.

I ask myself about the theatre—about its mystery and its essence. It's to do with time. The theatre, more tangibly than any other art, presents us with the past. Paintings may show what the past looked like, but they are like traces or footprints, they no longer move. With each theatre performance, what once happened is re-enacted. Each time we keep the same rendezvous: with Macbeth who can't wake up from his downfall; with Antigone who must do her duty. And each night in the theatre Antigone, who died three millennia ago, says: "We have only a short time to please the living, all eternity to please the dead."

Theatre depends upon two times physically co-existing. The hour of the performance and the moment of the drama. If you read a novel, you leave the present; in the theatre you never leave the present. The past becomes the present in the only way that it is possible for this to happen. And this unique possibility is theatre.

The Creationists, like all bigots, derive their fervour from rejection—the more they can reject, the more righteous they themselves feel. The Neo-Darwinists are trapped within the machine of their theory, in which there can be no place for creation as an act of love. (Their theory was born of the nineteenth century, the most orphaned of centuries.)

The ape theatre in Basel, with its two times, suggests an alternative view. The evolutionary process unfolded, more or less as the evolutionists suppose, within time. The fabric of its duration has been stretched to breaking point by billions of years. Outside time, God is still (present tense) creating the universe.

Silesius, after he left Strasbourg to return to Cracow, wrote: "God is still creating the world. Does that seem strange

to you? You must suppose that in him there is no before nor after, as there is here."

How can the timeless enter the temporal? the gorilla now asks me.

Can we think of time as a field magnetized by eternity? I'm no scientist. (As I say that, I can see the real ones smiling!) Which are they?

The ones up there on a ladder, looking for something. Now they're coming down to take a bow. . . .

As I say, I'm no scientist, but I have the impression that scientists today, when dealing with phenomena whose time or spatial scale is either immense or very small (a full set of human genes contains about 6 billion bases: bases being the units—the signs—of the genetic language), are on the point of breaking through space-time to discover another axis on which events may be strung, and that, in face of the hidden scales of nature, they resort increasingly to the model of a brain or mind to explain the universe.

"Can't God find what he is looking for?" To this question Silesius replied, "From eternity he is searching for what is lost, far from him, in time."

The orang-utan mother presses the baby's head against her chest.

BIRTH BEGINS THE PROCESS of learning to be separate. The separation is hard to believe or accept. Yet, as we accept it, our imagination grows—imagination which is the capacity to reconnect, to bring together, that which is separate. Metaphor finds the traces which indicate that all is one. Acts of solidarity, compassion, self-sacrifice, generosity are attempts to re-establish—or at least a refusal to forget—a once-known unity. Death is the hardest test of accepting the separation which life has incurred.

You're playing with words!

Who said that?

Jackie!

The act of creation implies a separation. Something that remains attached to the creator is only half-created. To create is to let take over something which did not exist before, and is therefore new. And the new is inseparable from pain, for it is alone.

One of the male chimps is suddenly angry. Histrionically. Everything he can pick up he throws. He tries to pull down the stage trees. He is like Samson at the temple. But unlike Samson, he is not high up in the group hierarchy of the cage. The other actors are nonetheless impressed by his fury.

Alone, we are forced to recognize that we have been created, like everything else. Only our souls, when encouraged, remember the origin, wordlessly.

Silesius's master was Eckardt, who, further down the Rhine beyond Strasbourg, in Cologne, wrote during the thirteenth century, "God becomes God when the animals say: God."

Are these the words which the play behind the soundproof plate glass is about?

In any case I can't find better.

HANDS OF HENRY MOORE.

INFANCY

THE HANDS, apparently, of an old person. Perhaps a woman. Hands, one might guess, which have gardened, washed, cooked, ironed, consoled and dressed babies, fed children, washed many heads of hair.

These hands made a drawing, a copy of a detail from Giovanni Bellini's most famous *pietà*. As in the original painting, the head of Mary is pivoted against the head of the dead Christ, as though the two heads were hinged cheek to cheek, and the death on the one had printed the grief on the other. Mary is holding Christ's hand, her forefinger and thumb framing the hole driven through the flesh by the hammered nail.

The copy is faithful but free, intelligently drawn, and full of feeling for the hinged bond of agony between mother and son. It was drawn in 1975 by Henry Moore.

I want to try to liberate us from some of the stereotypes and critical clichés which surround Moore's work five years after his death. These clichés are partly the result of his prestige as Britain's most important twentieth-century international artist, partly the consequence of so many blind glossy colour photos showing reclining figures with holes through them on cultural sites throughout the world, and partly a product of the spite which characterises a great deal of post-modernist opinion-making.

Post-modernism has cut off the present from all futures. The daily media adds to this by cutting off the past. Which means that critical opinion is often orphaned in the present, incapable of seeing beyond shrill and opportunist prejudices.

I want to ask a difficult but fundamental and therefore simple question: What is Henry Moore's art about? What are people across the world likely, in the future, to find in his sculpture? The photograph of his hands may eventually help us.

In history the most common subject for sculpture has been the human body. The link is through the sense of touch. Touch is the most corporeal of the body's five senses and sculptures demand to be touched. In the long run, nothing can change this. It's inscribed in the human imagination that sculpture must push towards the body. (Perhaps Brancusi's work is one of the most beautiful plastic demonstrations of this inherent tendency of the sculptured form to long for breath, to become a body.)

Most of Henry Moore's sculpture concerns the feminine body. Fathers and warriors arrived later, but they were passing. At the beginning and end was woman. Seen how? Seen and dreamt as what? Serving (as all impressive art must) what obsession?

The early drawings from posed models already suggest a clue. With their search to define mass—as distinct from contour or gesture, with their striving for solidity, they are clearly the drawings of a man who is determined to be a sculptor. But they indicate something more. This artist wants to *hold* the body he is drawing. He does not simply want to read and record it as, say, Raphael might have done. All his energy is directed to making marks on the paper in such a way that the body appears as graspable, as tangible. It is her existence, not her appearance, which obsesses him. Her presence, not

her message. He wants her to be *there*, prior to the reading of any sign emanating from her.

His first stone carvings of the early thirties, in which critics found an Aztec influence due to his studying the Mexican collection in the British Museum, express the same hope and the same need. The young woman in *The Girl with Clasped Hands* (1931) is grasping herself as if seeking assurance from her own solidity as proof of existence. The marvellous head and shoulders, in Cumberland alabaster, shows two arms making a circle and the two breasts nosing each other for company. A kind of self-embrace, except that that suggests something too pathetic and too narcissistic. These sculptures cannot be pathetic because they precede the normal language of emotion. They are earlier than sentiment. The consistent underplaying of the features of the face (eyes, mouth, chin, etc.) emphasizes this inarticulateness which we might term pre-verbal.

Moore's first geometric, non-figurative sculptures give a similar impression of unmistakable, reassuring, but mute presences. They have little or nothing to do with objects. All of them possess a kind of body warmth.

So where are we? We are before women whose physical presence, whose mass, whose warmth is all. If there is an eroticism about them, it is not addressed to men nor to sexuality as men usually feel it. (Moore's art has always escaped the puritan ban.) Rather his work addresses some vague memory of an experience in which everything was erotic and nothing was identifiable.

The theme of the Mother and Child came very soon. There is a drawing of 1933 in which a child lies curled in the lair of his mother's arms like a hibernating animal. There is a stone-carving of 1936 where the mother and child resemble the knuckles and thumb of a single clenched fist, their eyes as small and insignificant as worm holes in the sand.

Works like these announce the principal subject of fifty years of creativity still to come. Throughout his life, Moore searched—backwards—to find a way of expressing the child's experience of the mother's body.

Put like this, the project sounds simple enough, and yet it can easily be misunderstood. The originality of Moore's obsession and achievement makes it difficult to describe. Sometimes a thing is simpler done than said.

Psychoanalysis has had a considerable influence on our century's art, yet Moore, whose chosen subject was the primary pivotal relation between mother and child, had little or no interest in psychoanalitical theory. He was fascinated not by emotions but by touch: not by the deep unconscious but by surfaces and the tactile.

Imagine a baby carried, as in Africa, on the mother's back, its cheek between her shoulder blades, or, sometimes, lower down, against the small of her back. The surface of this back, like a pasture for the baby's sense of touch, is the creative field of hundreds of Moore's sculptures. Sleeping in the crook of the arm, cheek against the rounded shoulder, is another primary tactile experience of his art. As also the experience of knees, legs somewhat apart, across which the infant lies to be washed or changed. I leave the touched experience of the breast till last, for it is the most clear. In French the word for breast (*sein*) is also the word for womb. In drawings and in clay Moore often played with this duality which is so deeply embedded in our infancy but which adult perception may forget.

Now, however, we come to the most complex and, in a sense, paradoxical aspect of his art. To express these very old, mute, pre-verbal experiences, Moore did not choose (or invent) a primitive sculptural language, like, say, Dubuffet. On the contrary, he chose a classical language which maintained a continuity with Praxiteles or the Renaissance or the

Benin bronzes. His extraordinary ability, when he was at his best, to capture the tension of a form (energy pushing outwards from within) and, at the same time, to keep this form always surprising, when the spectator walks around it to discover the always *other* side—this derived from a highly sophisticated and traditional mastery of the art. When he was in his eighties, he still made painstaking drawings of trees or sheep as Mantegna or Gericault might have done. He was both an innovator—because he imported a totally new aspect of tactile experience into sculpture—and a traditionalist. And this was the only way to do what he wanted to do.

If he had invented a primitive language, the experiences expressed would have remained isolated in infancy. Some works might have prompted memories of things forgotten, but the refound memories could never have become universal. They would have remained local and infantile. What Moore wanted to do—or what the demon of his obsession obliged him to do—was to make space for the infantile within a classical view of the human body. To include the infantile not by way of anecdote or circumstance—with one exception the most deeply maternal of his figures are those where no child is present in the sculpture—but through an evocation of a special way of touching forms and being touched by them.

His figures, however small, all look like giants. Why? They have been perceived, imaginatively, by tiny hands. Their surfaces are like landscapes because they have been felt so close up. Their notorious hollows and holes are sites of a sensation of enclosure, cradling, nuzzling. Before Moore's art, as before nobody else's, we are reminded that we are mammals.

If the recurrent theme of his work is infancy, this is not of course to say that everything Moore did should only be considered in this light. Watteau's recurrent theme was mortality; Rodin's submission, Van Gogh's work, Toulouse-

Lautrec's the breaking point between laughter and pity. We are talking about obsessions which determine the gestures and perceptions of artists throughout a life's work, even when their conscious attention is elsewhere. A kind of bias of the imagination. The way a life's work slips towards a theme which is home for that artist.

Moore's work was uneven. He produced, in my opinion, his weakest sculptures during the period when his work was most in demand and most critically unquestioned. I remember that towards the end of the fifties, when I had the temerity to write critically about his latest work, I very nearly lost my job on the *New Statesman*. I was considered a national traitor!

Because of its underlying theme of pre-verbal experience, his work lent itself to a special kind of cultural appropriation. It could easily be covered with words, and so become all things to all men. Its universality became an alibi for very diverse uses. A Henry Moore became an emblem for Time-Life and, at the same time, for UNESCO!

It's not of course the first time such a thing had happened in the history of art. Fashion and the *beaux-arts* have a tendency to become dancing partners. Only in a work's second life, after its first death, can it insist upon its own terms.

During the fifties and sixties Moore was often distracted by ambition. Or rather—for in reality he remained a modest man—his art was distracted by other people's ambitions for it. It lost sight of its obsession and lent its obsessive language to rhetoric. No energy pushed out from within. The *King and Queen* of 1952–53 is for me a perfect example of this highly productive but comparatively barren period.

By contrast, the last period of Moore's working life—and notably the years when he was in his late seventies or over eighty—was of an incomparable richness. Here he joins the company of Titian or Matisse in the sense that his life's work becomes cumulative, his last works an apogee. At the end he

found—magnificently—the way back to what he was always hoping to find.

Let us take the *Mother and Child: Block Seat* (1983–1984). The mother is seated. One of her arms is like the arm of an upholstered chair, on which the child balances like a Mexican jumping bean. Her other arm is relaxed, its relatively naturalistic hand hovering above her lap. Both their faces are featureless. The two "features" which the sculpture possesses are elsewhere. One is the nipple of her left breast, which does not stand up, but is a hole like a mouth of a sentient bottle; and the other is a protuberance on the child's face which is like an eventual stopper for that hole, a stanch for that wound, a life for that nourishment.

I don't like puns, but if I try to approach the emotions generated by this last or almost last sculpture by Henry Moore, I can't get round the word "mummy." Except perhaps for the mother's hand over the lap, all the forms are encased, swathed, bound as were those of the Egyptian dead. Enveloped for eternal survival. There is the same urgent sense of what is within. The sculpture is not, of course, upright and rigid like a mummy in its case, and it includes not a single figure but two. Yet the limbs and bodies have been similarly bound, dressed, handled. Not this time so that they should be hidden and protected, but so that their new exterior surface resembles the close-up of the first body we ever touched.

The last rite of the Egyptian burying ceremony was the opening of the mouth. The son of the deceased, or a priest, solemnly opened the mouth, and this act allowed the dead person who was in the other world to speak, to hear, to move, to see. In Henry Moore's last great work the mouth has become the mother's nipple.

THE OPPOSITE
OF NAKED

PAINTING BY RENOIR.

AMONG THE FRENCH IMPRESSIONISTS, Renoir is still the most popular. All over the world his name is associated with a particular vision of sunlight, leisure and women. This would have pleased him. It was for his paintings of women— and particularly for his nudes—that he believed he would be admired and remembered.

I believe he will remain a widely popular painter, because his work is about pleasure. But pleasure in what exactly? Or, to put it another way, what does Renoir's way of painting— which is so instantly recognizable—really reveal to us?

A male dream of goddesses? An eternal summer of full-fleshed happy women? Daily domesticity treated as recurring honeymoon? Some of this. But what has been *replaced*? What is crying out because it is not there, has not been included?

All the photographs of Renoir—from the first in 1861 when he was twenty to the last when, nearly eighty, he could only paint by having the brushes strapped to his arthritic hand—show a nervous, lean, vulnerable man. About half-way through his life the expression in his eyes changes: from being shy and dreamy, it becomes a little fixed and fanatical. This change, occurring around 1890, corresponds more or less with three other developments: his settling down into marriage, his achieving financial security, and the first signs of the rheumatoid arthritis which was to cripple him, yet in face of which his obstinacy and courage were very impressive.

These photographs remind us that what is banished from Renoir's paintings is any sign of anguish, any possibility of choice. He often said that he painted for his own pleasure and to give pleasure. Yet for him the pre-condition of pleasure was the fantasy of a world without edges, without sharpness or conflict, a world that enveloped like a mother's open blouse and breast. Pleasure for him was not for the *taking*: it had to be ubiquitous and omnipresent. You have to embellish, he said; paintings should be friendly, pleasurable and pretty. And about this, as he grew older, he became fanatical: "The best exercise for a woman is to kneel down and scrub the floor, light fires or do the washing—their bellies need movement of that sort." By this he meant that such work produced the kind of belly he found friendly and pleasurable.

His son, the film director Jean Renoir, has written a remarkable book about his childhood memories. In it there is this conversation with his father:

> "Whose music is that?"
> "Mozart's."
> "What a relief. I was afraid for a minute it was that imbecile Beethoven . . . Beethoven is positively indecent the way he tells about himself. He doesn't spare us either the pain in his heart or in his stomach. I have often wished I could say to him: what's it to me if you are deaf?"

Nothing is simpler than to ridicule a past age, and nothing is more ridiculous. It is not by our own virtue today that we are closer to Beethoven. Feminist reasoning applied retrospectively to Renoir is too easy. I use these quotations only to indicate how threatened Renoir often felt. He was, for instance, obsessional about the safety of his children: all sharp edges had to be sawn off the furniture, no razor-blades were

allowed inside the house. Only if we appreciate Renoir's fears can we better understand *how* he painted.

Now I want to add one more element to the riddle of the meaning of Renoir's oeuvre. He was born in 1841. His father was a tailor who worked at home. His mother was a dressmaker. Very soon the father's trade began to diminish, as more and more factory-made clothes came on to the market in the second half of the nineteenth century. The immensity of any childhood begs description. Yet we can suppose that in this childhood home there was already a certain nostalgia for the security of the past and that this nostalgia was intimately associated with cottons, silks, organdies, tulles, taffetas—clothes.

The exact nature of Renoir's anxiety—which became more acute as he settled down into a successful, secure life—we can never know. Some aspect of reality frightened him—as may happen to any of us. Yet Renoir was a painter working directly from the real. And so his imagination and his senses lead him to develop a way of painting which transformed the real, which banished fears and consoled him. You have to embellish, he said. How?

By muffling, by covering, by draping, by dressing. He studied the surface or the skin of everything he saw before his eyes, and he turned this skin into a veil which hid what lay behind the surface—the real that frightened him.

This process which generated all the energy of his vision (painting as an act not of disclosing but of covering) had two obvious consequences. When he painted coverings, when he painted cloth, there was a complicity between the *stuff* and his vision of it which is unique for its freedom in the history of art. He painted the dreams of dressing as no other artist except Watteau has ever done. Sometimes I imagine him before his easel, having almost stopped breathing, his eyes screwed up, with pins in his mouth like his mother.

Think of *La Danse à Bougival* and you'll see a warm dress dancing with a sweating suit and two hats breathing each other's perfumes. What about the hands? you ask. But look again, the hands are like gloves. What about her pretty face? It's as if painted with face-powder and it's a pretty mask.

Think of *Le Déjeuner des Canotiers*, where you have, at the end of a summer lunch, a rumpled pearly table-cloth with discarded napkins which are like a concert of singing angels. And the bottles and the dog's coat and the man's vest and the hats and scarves, all the *confection*, as the French say, is singing; only the figures are mute because lacking substance.

Renoir did not paint many landscapes, but when he did, his vision transformed them into something like chintz cushion covers. Landscapes are frightening because they imply exits and entrances. Renoir's are not, because there is no gravity, no resistance, no edges, no horizon. You simply lie your cheek on them. It is interesting to speculate what Renoir, in another age, might have designed for tapestries—the medium would have curiously touched his genius.

The second consequence of Renoir's relation to reality and the salvation which painting offered him is to be found in the way he painted women and their bodies. And here, if one really looks, one discovers something which, given his reputation, is a little surprising. The women he depicts are never naked; they and everything around them are clothed, covered, by the act of painting. He made hundreds of nudes and they are the least present, the most chaste in European art.

He paints their flesh, their skin, the light playing on it. He observes this with the sweet obsessiveness of love. (I reject the word fetishism because it is too patronizing.) Nobody before had watched this play of light with such single-minded concentration—not even Titian. It is the light of the early Mediterranean afternoon, when work has stopped and only

the bees maintain their energy. Looking at these paintings, we enter a kind of paradise, an Eden of the sense of touch. (He forbade his children to cut their nails, for they protected the sensibility of their fingertips.) Yet what is within these dappled skins and what is without?

Within, there is nobody—the living flesh, so alive, is the equivalent of a dress that nobody is wearing. Without—beyond the body's limits—there are trees or rocks or hills or the sea, but all these prolong and extend the same paradise. Every conflict, every edge of difference and distinction has been eliminated. Everything—from the silicate rocks to the hair falling on a woman's shoulders—is homogeneous, and as a consequence, there is no identity, because there are no dualities. We are faced with a cloth of delight that covers all. This is why the paintings are so chaste.

Passion begins with a sense of the uniqueness, the solitude, the vulnerability of the loved one in a harshly indifferent world. Or, to put this in an active rather than a passive mood, it begins with the loved one's impudence, defiance or promise of an alternative. In an unfeeling world such a promise becomes like a well in a desert. None of this exits in Renoir's world because there are no contrasts and no edges. Everything has been dressed by the act of painting. The paradox is strange. We gaze at shoulders, breasts, thighs, feet, mounds, dimples, and we marvel at their softness and warmth. Yet everything has been veiled. Everything, however apparently intimate, is in purdah—for the person has been eternally hidden.

They are sweet paintings of a terrible loss. They speak to the dreams of frightened men, their obsession with the surface of femininity, and their lack of women. Perhaps they also speak to some women's dreams: those dreams in which the guise of femininity alone can arrange everything.

"Me," Renoir once said, "I like paintings which make

me want to take a stroll in them if they're landscapes, and if they're figures of women, to touch their breasts ("tits" is closer to the word he used) or their backs." The wish, the fantasy, is timeless. Passion and the erotic, as John Donne knew so well, are not:

> For I had rather owner be
> of thee one hour, than all else ever.

A HOUSEHOLD

OVERLEAF: PAINTING OF *THE HOLY HOUSE OF NAZARETH* BY
ZURBARÁN.

169

IT WAS SEVEN YEARS AGO, in the National Gallery in Stockholm, that I first became really interested in Zurbarán. Zurbarán, renowned during his lifetime in the seventeenth century, has again become eloquent at the end of ours, the twentieth. I want to try to discover why this might be so.

The painting in Stockholm which stopped me in my tracks was of Veronica's Veil. (He painted several versions.) The white kerchief is pinned to a dark wall. Its realism is such that it borders on trompe l'oeil. Rubbed on to the white linen (or is it cotton?) are the traces of Christ's face, haggard and drawn as he carried the cross to Golgotha. The imprint of the face is ochre-coloured and monochrome, as befits an image whose medium was sweat.

The canvas in Stockholm made me realize something which applies, I think, to any visual work of art that has the power to move us. Painting first has to convince us—within the particular use of the pictorial language it is using—of what is *there*, of the reality of what it depicts. In the case of Zurbarán, of the kerchief pinned to the wall. Any painting which is powerful first offers this certitude. And then it will propose a doubt. The doubt is not about *what* is there, but about *where* it is.

Where is the face so faintly printed on the kerchief? At what point in space and time are we looking? It is there, it

touches and even impregnates the reality of the cloth, but its precise whereabouts is an enigma.

Before any impressive painting one discovers the same enigma. The continuity of space (the logic of the whereabouts) will somewhere on the canvas be broken and replaced by a haunting discontinuity. This is as true of a Caravaggio or a Rubens as of a Juan Gris or a Beckmann. The painted images are always held within a broken space. Each historical period has its particular system of breaking. Tintoretto typically breaks between foreground and background. Cézanne miraculously exchanges the far for the near. Yet always one is forced to ask: what I'm being shown, what I'm being made to believe in, is exactly where? Perspective cannot answer this question.

The question is both material and symbolic, for every painted image of something is also about the absence of the real thing. All painting is about the presence of absence. This is why man paints. The broken pictorial space confesses the art's wishfulness.

Let us now return to what is specific to Zurbarán. One of his early paintings shows St. Pierre Nolasque kneeling before the apparition of St. Peter, crucified upside down on his cross. Nolasque kneels on solid, solid ground. The crucified saint, who is the same size as the living figure, is a vision from beyond time and space. And on the ground where the two spaces (one solid, the other visionary) are hinged, Zurbarán has placed his signature. He was the master of such hinges. They were his life's obsession.

What sort of man was he? Apart from his paintings and the commissions he received, we know little about him. A supposed self-portrait—he is standing with his painter's palette at the foot of the Cross—shows us a rather indecisive man who is both devout and sensuous. A contemporary of Velázquez, he worked not for the sophisticated royal court

but almost exclusively for the Spanish Church at the height of its fanatical Counter-Reformation. A large number of his canvases were painted especially for monasteries. I should perhaps say that I have a visceral antipathy for the kind of religious institution for which Zurbarán worked. Cults of martrydom, flagellation, saints' relics, damnation and inquisitorial power are for me detestable. All my spiritual sisters and brothers were its victims. Yet for years this man's art has—not fascinated me, for one can be fascinated by horror—but touched me, made me dream. It took me a long time to guess why.

Zurbarán was married three times and was the father of nine children—most of whom in the age of the plague died before he did. He worked for the monasteries, yet his inspiration was domesticity—an inspiration which became more and more obvious during the course of his life. Not the domesticity of a paterfamilias or a bourgeois male moralist (sufficient here to compare his paintings with Dutch contemporaries like Jan Steen), but a domesticity which accrues through labour: childbirth, ironed linen, prepared food, fresh clothes, arranged flowers, embroidery, clean children, washed floors. His art is infused, as that of no other painter of his time, by the experience, pride and pain of women— and, in this sense, is very feminine. Perhaps it was this "contraband," carried in by his paintings, which created such a demand for them among the religious orders?

In qualifying Zurbarán's vision as domestic, I am not only thinking of certain favourite subjects he painted, or of the turn he gave to certain subjects (his Immaculate Conceptions are perfumed like layettes), but, more profoundly, of the way he envisaged almost any scene he was ordered to paint. For example, in an early painting of the monstrously tortured St. Serapion, what we actually see in his picture are the hands and head of a peasant husband asleep, and the robes hanging

from his body, like precious linen tousled by the wind on a clothes-line. It isn't that the subject has been secularized; it is rather that the life of the soul has been thought of, has been tended, and finally, has been saved, like the life of a household.

Art historians point out that Zurbarán remained in some ways a provincial painter. He was never at ease in the grand architecture of ambitious compositions. This is true. His genius lay in making a shelter, a home of *corners*.

Let us go to *The Holy House of Nazareth* (in Cleveland). On the right, Mary imagining the future; on the middle finger of her right hand a thimble, by the flank of her nose a tear. On the left, her son Jesus, who is making a crown of thorns, one of which has pricked his finger. Between them a kitchen table. Every object in the picture has its symbolic tag: the two turtle doves are for the Purification of the Virgin after the birth of her child; the fruit on the table for Redemption; the lilies for Purity, and so on. In the seventeenth century, such scenes from the childhood of Christ, and also from the childhood of the Virgin (another subject which Zurbarán loved), were widely popular and were controlled and distributed by the Church as models of devotion and patience. None of this, however, explains the image's emotional charge. The French painter Laneuville, who was a pupil of David, wrote in 1821 about "the magic" of this canvas.

The magic begins, as I've said, with a doubt following a certitude. It begins with a spatial break, a discontinuity. The foreground of the floor is continuous right across the canvas. The hinge of the discontinuity is the nearest leg of the table.

From his knees upwards, the child is placed in a space that is indefinable, and opens on to angels. To the right of the table leg, in the territory of the mother, the space remains that of a room in a house—even the window, or picture, on the wall takes up its everyday position.

The table-top, impossibly upturned towards us, mediates between the two spaces. The pages of the open book on the left flicker in the light of the angels. The two books on the right are unmistakably placed on the kitchen table.

The two different spaces correspond with two different times: on the right everyday time, every nightime: on the left the time of prophesy, pierced time—like the boy's finger pierced by the thorn.

We come now to the psychic spatial discontinuity—to the narrative jolt which, given the rest, increases further the picture's extraordinary charge. It is the sight of her boy which is making the mother so pensive. The sight reminds her of his future. She foresees their destiny. *And yet she is not looking at him.* Spatially, she is simply not looking in his direction. It is we who are looking at two spaces. She, confined to one, *knows.*

Mothers in Nazareth today, foreseeing the tragic destiny of their sons, are Palestinians. I say this to recall us to the century in which we are living. What does Zurbarán mean in our contemporary world?

Let us first be clear. It is no longer a single historical world—as it has been from the beginning of the nineteenth century onwards. Nor is it any longer ours. We, in our culture of commodities, are living our crisis; the rest of the world are living theirs. Our crisis is that we no longer believe in a future. Their crisis is us. The most we want is to hang on to what we've got. They want the means to live.

This is why our principal preoccupations have become private and our public discourse is compounded of spite. The historical and cultural space for public speech, for public hopes and action, has been dismantled. We live and have our being today in private coverts.

The fact that Zurbarán's art is domestic means it is an art to which we are not necessarily closed. By contrast, public

art—whether it be that of Piero della Francesca, Rubens, Poussin, David or the cubists—leaves us cold. (The debate of post-modernism is simply about the loss of public nerve.) Zurbarán's art of the interior suits our fear of the outside.

Once we are inside with him, we are intrigued, troubled, and obliged to dream about the colossal difference between the life he paints and ours. Everything he paints looks as if it is eternal. (His eternity has a lot to do with childhood.) Everything with which we surround ourselves feels as if it's disposable. Return to the marvelous house in Nazareth.

Her sewing, the cushion on her lap, her dress the colour of pomegranates, the chiffon scarf round her neck, her cuffs, the hand holding her head, her lips, are as present as a Manet or Degas might have wished, painted with a tactile intensity which reminds one yet again that only the eye can do justice to the phenomenon of existence. And yet, present as she is, the expression of her eyes shows she is also elsewhere. The hinge of the two spaces within the picture is a visible one. A similar but invisible hinge exists within the being of this woman.

Zurbarán painted a few still lifes of jars, cups, fruit. The objects are invariably placed on the edge of a table (or shelf) against a dark background. Under them, beneath the table, or, above and behind them, there is a darkness which may be nothingness. What is visible has been placed on the very edge of this darkness, as if somehow the visible has come through the darkness like a message. Everything and everybody in the house at Nazareth has a similar quality of being or receiving a message. And so, quite apart from the fact that the subject is a prophecy concerning the Holy Family—everything in the painting is perceived as being sacred.

What do I mean by sacred? "Set apart because holy," as the dictionary suggests? Why holy? On account of the angels? No—curiously enough, angels in the sky are the least holy

thing in Zurbarán's repertoire. (They are simply a fond parent's baby fantasies.) His sense of the sacred comes not from symbolism but from a way of painting and of placing. In everything he paints, he sees not only a form but a task accomplished or being accomplished. The tasks are everyday household ones such as I have already mentioned. They imply care, order, regularity: these qualities being honoured not as moral categories but as evidence of meaning, as a message. Any peasant not entirely dispossessed of his land would recognize what I'm talking about here. It is where, against the chaos of nature, a sense of achievement includes aesthetics. It is why, if possible, the wood is stacked and not just thrown into a corner. Against the myriad natural risks, daily acts of maintenance acquire a ritual meaning.

In Zurbarán's art we don't find the chaos of nature, but we do find a background—as in all Spanish art—which is blackness: the blackness represents the world into which we have been thrown like salt into water.

It is not Zurbarán's saints or martyrs or angels that emanate a sense of the sacred for us, but the intensity of his looking at what has been worked upon against this background, and his knowledge that human space is always broken and twofold. Such knowledge comes through compassion, for which there is no space in our culture of greed. As for ritual acts—such as making a cup of coffee or tea—they are still performed every day, and within a family or between an old couple, they may still preserve a meaning, but publicly there are no everyday ritual acts, for a ritual requires a permanent sense of past and future and in our culture of commodities and novelties there is neither.

Zurbarán has become eloquent at the end of our century because he paints stuff—stuff one might find in a flea market—with a concentration and care that reminds us how once it may have been sacred.

DRAWING ON
PAPER

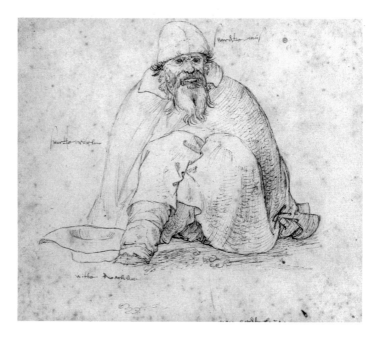

SEATED MAN. DRAWING BY ROELANDT SAVERY.

I STILL SOMETIMES have a dream in which I am my present age with grown-up children and newspaper editors on the telephone, and in which nevertheless I have to leave and pass nine months of the year in the school to which I was sent as a boy. As an adult, I think of these months as an early form of exile, but it never occurs to me in the dream to refuse to go. In life I left that school when I was sixteen. The war was on and I went to London. Amongst the debris of bomb sites and between the sirens of the air-raid warnings, I had a single idea: I wanted to draw naked women. All day long.

I was accepted in an art school—there was not a lot of competition, for nearly everyone over eighteen was in the services—and I drew in the daytime and I drew in the evenings. There was an exceptional teacher in the art school at that time—an elderly painter, a refugee from fascism named Bernard Meninsky. He said very little and his breath smelt of dill pickles. On the same imperial-sized sheet of paper (paper was rationed; we had two sheets a day), beside my clumsy, unstudied, impetuous drawing, Bernard Meninsky would boldly draw a part of the model's body in such a way as to make its endlessly subtle structure and movement clearer. After he had stood up and gone, I would spend the next ten minutes, dumbfounded, continuously looking from his drawing to the model and vice versa.

Thus I learnt to question with my eyes a little more

probingly the mystery of anatomy and of love, whilst outside in the night sky, audibly, RAF fighters were crossing the city to intercept the approaching German bombers before they reached the coast. The ankle of the foot on which her weight was posed was vertically under the dimple of her throat—directly vertical.

Recently I was in Istanbul. There I asked my friends if they could arrange for me to meet the writer Latife Tekin. I had read a few translated extracts from two novels she had written about life in the shanty towns on the edge of the city. And the little I had read had deeply impressed me by its imagination and authenticity. She must herself have been brought up in a shanty town. My friends arranged a dinner and Latife came. I do not speak Turkish and so naturally they offered to interpret. She was sitting beside me. Something made me say to my friends, "No, don't bother, we'll manage somehow."

The two of us looked at each other with some suspicion. In another life I might have been an elderly police superintendent interrogating a pretty, shifty, fierce woman of thirty repeatedly picked up for larceny. In fact, in this our only life we were both story-tellers without a word in common. All we had were our powers of observation, our habits of narration, our Aesopian sadness. The suspicion between us gave way to shyness.

I took out a notebook and did a drawing of myself as one of her readers. She drew a boat upside down to show she couldn't draw. I turned the paper around so it was the right way up. She made a drawing to show that her drawn boats always sank. I said there were birds at the bottom of the sea. She said there was an anchor in the sky. (Like everybody

else, we were drinking raki.) Then she told me a story about
the municipal bulldozers destroying the houses built in the
night. I told her about an old woman who lived in a van. The
more we drew, the quicker we understood. In the end, we
were laughing at our own speed—even when the stories were
monstrous or sad. She took a walnut and, dividing it in two,
held it up to say, Halves of the same brain! Then somebody
put on some Bektasi music and the company began to dance.

IN THE SUMMER OF 1916, Picasso drew on a page of a
middle-sized sketchbook the torso of a nude woman. It is
neither one of his invented figures—it hasn't enough bra-
vura—nor a figure drawn from life—it hasn't enough of the
idiosyncracy of the immediate.

The face of the woman is unrecognizable, for the head
is scarcely indicated. Yet the torso is also like a face. It has
a familiar expression. A face of love become hesitant or sad.
The drawing is quite distinct in feeling from the others in
the same sketch-book. The other drawings play rough games
with cubist or neo-classical devices, some looking back on the
previous still-life period, others preparing the way for the
Harlequin themes he would take up the following year when
he did the decor for the ballet *Parade*. The torso of the woman
is very fragile.

Usually, Picasso drew with such verve and such direct-
ness that every scribble reminds you of the act of drawing
and of the pleasure of that act. It is this which makes his
drawings insolent. Even the weeping faces of the *Guernica*
period or the skulls he drew during the German occupation
possess an insolence. They know no servitude. The act of
their drawing is triumphant.

The drawing in question is an exception. Half-drawn—

for Picasso didn't continue on it for long—half woman, half
vase; half seen as by Ingres, half seen as by a child; the
apparition of the figure counts for far more than the act of
drawing. It is she, not the draughtsman, who insists, insists
by her very tentativeness. My hunch is that in Picasso's imagination this drawing
belonged somehow to Eva Gouel. She had died only six months
before of tuberculosis. They had lived together—Eva and
Picasso—for four years. Into his now-famous cubist still lifes
he had inserted and painted her name, transforming austere
canvases into love letters. JOLIE EVA. Now she was dead and
he was living alone. The image lies on the paper as in a
memory.

This hesitant torso—re-become more child than
woman—has come from another floor of experience, has come
in the middle of a sleepless night and still has the key to the
door of the room where he sleeps.

PERHAPS THESE THREE STORIES suggest the three dis-
tinct ways in which drawings can function. There are those
which study and question the visible, those which put down
and communicate ideas, and those done from memory. Even
in front of drawings by the old masters, the distinction be-
tween the three is important, for each type survives in a
different way. Each type of drawing speaks in a different
tense. To each we respond with a different capacity of
imagination.

In the first kind of drawing (at one time such drawings
were appropriately called *studies*) the lines on the paper are
traces left behind by the artist's gaze, which is ceaselessly
leaving, going out, interrogating the strangeness, the enigma,
of what is before his eyes, however ordinary and everyday

this may be. The sum total of the lines on the paper narrate a sort of optical emigration by which the artist, following his own gaze, settles on the person or tree or animal or mountain being drawn. And if the drawing succeeds, he stays there for ever.

In a study entitled *Abdomen and Left Leg of a Nude Man Standing in Profile*, Leonardo is still there: there in the groin of the man, drawn with red chalk on a salmon-pink prepared paper, there in the hollow behind the knee where the femoral biceps and the semimembranous muscle separate to allow for the insertion of the twin calf muscles. Jacques de Gheyn (who married the rich heiress Eva Stalpaert van der Wiele and so could give up engraving) is still there in the astounding diaphanous wings of the dragonflies he drew with black chalk and brown ink for his friends in the University of Leyden in 1600.

If one forgets circumstantial details, technical means, kinds of paper, etc., such drawings do not date, for the act of concentrated looking, of questioning the appearance of an object before one's eyes, has changed very little throughout the millennia. The ancient Egyptians stared at fish in a comparable way to the Byzantines on the Bosphorus or to Matisse in the Mediterranean. What changed, according to history and ideology, was the visual rendering of what artists dared not question: God, Power, Justice, Good, Evil. Trivia on the side could always be visually questioned. This is why exceptional drawings of trivia carry with them their own "here and now," putting their humanity into relief.

Between 1603 and 1609 the Flemish draughtsman and painter Roelandt Savery travelled in Central Europe. Eighty drawings of people in the street—marked with the title *Taken from Life*—have survived. Until recently, they were wrongly thought to be by the great Pieter Breughel. One of them, drawn in Prague, depicts a beggar seated on the ground.

He wears a black cap; wrapped round one of his feet is a white rag, over his shoulders a black cloak. He is staring ahead, very straight; his dark sullen eyes are at the same level as a dog's would be. His hat, upturned for money, is on the ground beside his bandaged foot. No comment, no other figure, no placing. A tramp of nearly four hundred years ago. We encounter him today. Before this scrap of paper, only six inches square, we *come across* him as we might come across him on the way to the airport, or on a grass bank of the highway above Latife's shanty town. One moment faces another and they are as close as two facing pages in today's unopened newspaper. A moment of 1607 and a moment of 1987. Time is obliterated by an eternal present. Present Indicative.

IN THE SECOND CATEGORY of drawings the traffic, the transport, goes in the opposite direction. It is now a question of bringing to the paper what is already in the mind's eye. Delivery rather than emigration. Often such drawings were sketches or working drawings for paintings. They bring together, they arrange, they set a scene. Since there is no direct interrogation of the visible, they are far more dependent upon the dominant visual language of their period and so are usually more datable in their essence: more narrowly qualifiable as Renaissance, Baroque, Mannerist, Eighteenth-century, Academic, or whatever.

There are no confrontations, no encounters to be found in this category. Rather we look through a window on to a man's capacity to dream up, to construct an alternative world in his imagination. And everything depends upon the space created within this alternative. Usually, it is meagre—the direct consequence of imitation, false virtuosity, mannerism.

Such meagre drawings still possess an artisanal interest (through them we see how pictures were made and joined—like cabinets or clocks), but they do not speak directly to us. For this to happen the space created within the drawing has to seem as large as the earth's or the sky's space. Then we can feel the breath of life.

Poussin could create such a space; so could Rembrandt. That the achievement is rare in European drawing (less so in Chinese) may be because such space only opens up when extraordinary mastery is combined with extraordinary modesty. To create such immense space with ink marks on a sheet of paper one has to know oneself to be very small.

Such drawings are visions of "What would be if . . ." The majority of them record visions of the past which are now closed to us, like private gardens. When there is enough space, the vision remains open and we enter. Tense Conditional.

T HIRDLY, there are the drawings done from memory. Many are notes jotted down for later use—a way of collecting and of keeping impressions and information. We look at them with curiosity if we are interested in the artist or the historical subject. (In the fifteenth century the wooden rakes used for raking up hay were exactly the same as those still used in the mountains where I live.)

The most important drawings in this category, however, are made in order to exorcise a memory which is haunting, in order to take an image once and for all out of the mind and put it on paper. The unbearable image may be sweet, sad, frightening, attractive, cruel. Each has its own way of being unbearable.

The artist in whose work this mode of drawing is most

obvious is Goya. He made drawing after drawing in a spirit of exorcism. Sometimes the subject was a prisoner being tortured by the Inquisition to exorcise his or her sins: a double, terrible exorcism.

I see a red-wash and sanguine drawing by Goya of a woman in prison. She is chained by her ankles to the wall. Her shoes have holes in them. She lies on her side. Her shirt is pulled up above her knees. She bends her arm over her face and eyes so she need not see where she is. The drawn page is like a stain on the stone floor on which she is lying. And it is indelible.

There is no bringing together here, no setting of a scene. Nor is there any questioning of the visible. The drawing simply declares: I saw this. Historic Past Tense.

A DRAWING from any of the three categories, when it is sufficiently inspired, when it becomes miraculous, acquires another temporal dimension. The miracle begins with the basic fact that drawings, unlike paintings, are usually monochrome. (If they are coloured, they are only partially coloured.)

Paintings with their colours, their tonalities, their extensive light and shade, compete with nature. They try to seduce the visible, to *solicit* the scene painted. Drawings cannot do this. The virtue of drawings derives from the fact that they are diagrammatic. Drawings are only notes on paper. (The sheets rationed during the war! The paper napkin, folded into the form of a boat and put into a raki glass where it sank.) The secret is the paper.

The paper becomes what we see through the lines, and *yet* remains itself. Let me give an example. A drawing made in 1553 by Pieter Brueghel (in reproduction its quality would

be fatally lost: better to describe it). In the catalogues it is identified as a *Mountain Landscape with a River, Village and Castle.* It was drawn with brown inks and wash. The gradations of the pale wash are very slight. The paper lends itself between the lines to becoming tree, stone, grass, water, masonry, limestone mountain, cloud. Yet it can never for an instant be confused with the substance of any of these things, for evidently and emphatically it remains a sheet of paper with fine lines drawn upon it.

This is both so obvious and—if one reflects upon it—so strange that it is hard to grasp. There are certain paintings which animals could read. No animal could ever read a drawing.

In a few great drawings, like the Brueghel landscape, everything appears to exist in space, the complexity of everything vibrates—yet what one is looking at is only a project on paper. Reality and project become inseparable. One finds oneself on the threshold before the creation of the world. Such drawings, using the Future Tense, *foresee*, forever.

HOW FAST
DOES IT GO?

(For Yves, le motard)

FRENCH POSTCARD.

190

CHEZERY-
FORENS

191

THE MORE I LOOK AT those photographs, the more baffled I become. I wonder, for an instant, whether this may be the result of my mind becoming tired. The photos themselves are not confusing; on the contrary, as photos go, they are, at first reading, straightforward. Pictures of ordinary places. Almost like a land-surveyor or a police inspector might take.

The four images come from a book of black-and-white photographs picturing one hundred and one rural communes around Belfort, France. They have names like St. Dizier-l'Evêque, Lagrange, Chaux, Felon. What could be more *terre à terre?* Then, why the vertigo? Why this kind of *extremis?* Before what?

ALL PHOTOGRAPHS are there to remind us of what we forget. In this—as in other ways—they are the opposite of paintings. Paintings record what the painter remembers. Because each one of us forgets different things, a photo more than a painting may change its meaning according to who is looking at it.

The thrill found in a photograph comes from the onrush of memory. This is obvious when it's a picture of something we once knew. That house we lived in. Mother when young.

But in another sense, we once knew everything we rec-

192

ognize in any photo. That's grass growing. Tiles on a roof get wet like that, don't they? Here is one of the seven ways in which bosses smile. This is a woman's shoulder, not a man's. Just the way snow melts.

Memory is a strange faculty. The sharper and more isolated the stimulus memory receives, the more it remembers; the more comprehensive the stimulus, the less it remembers. This is perhaps why black-and-white photography is paradoxically more evocative than colour photography. It stimulates a faster onrush of memories because less has been given, more has been left out. Those who have never set foot in the Franche-Comté have, nevertheless, partly been to the four places in the four photos before me; there are many things they will remember.

THEY HAVE been there. Yet where is it? I could find the communes on the map. But this doesn't answer the question. To arrive at any one of these sites, to refind what has been seen, one would have to travel. Yet the sight would never be refound for the moment has passed. If, however, one travelled in the right manner, there would be a good chance of finding something very similar—even a thousand kilometres away! It depends upon how one gets there, for the place is a state of mind rather than a point on an ordnance map.

These photographers set out to look, but they didn't know what they were looking for. On certain tourist maps spectacular views are marked like this:

$$\searrow\!|\!\swarrow$$

The photographers making this book were looking for what nobody had before charted, yet not for virgin lands where

193

nobody has ever been. They were looking for what people see functionally everyday—this is where one crosses the road to go to the baker's; this is where the horse shelters when it's raining; this is where Gaston was cutting wood last autumn—they were looking for what people see functionally everyday, but never frame in their minds. They were seeking a country between the familiar and the never-seen. And to arrive there, in this country, one has to travel in a special way.

It's not sufficient to look through a window. Nor will any highway take you there. Nobody can give you directions, since you don't know what to ask for. On this journey a much-trodden path is a warning rather than an encouragement. At the same time, the site isn't bound to be either desolate or wild. It may be just beside where the baker regularly parks his car. The art is to arrive there by accident. Then one surprises the place, and its surprise surprises you.

LOOKING AT THESE PHOTOS I have the impression I've just arrived by motor bike. This is also a special way of travelling. Except for the protective gear you're wearing, there's nothing between you and the rest of the world. The air and the wind press directly on you. You are *in* the space through which you are travelling. There is no vessel around you. But also, because you are on two wheels and not four, you are much closer to the ground. Not necessarily nearer. Many cars are lower than bikes. By closer I mean more intimate with. The surface of the road, for instance. You are conscious of all its possible variations, whether it offers a grip or is smooth, whether it's new or used, wet, damp or dry, where there's mud or gravel, where it's painted white (the painted surface is always more slippery), where there's metal, where the wind blows dust, where ruts are being worn—all the while you are

aware of the hold of the tyres or their lack of it on the varying surfaces, and you drive accordingly. Bends produce another intimate effect. If you enter one properly, it holds you in its arms. A hill points you to the sky. A descent lets you dive into it.

Every contour line on the map of the country you're driving through means your axis of balance has changed. There's an ongoing stability, of course, but this is the result of continuous minor adaptations, following from what you've just perceived a fraction of a second earlier. This perception is visual but also tactile and rhythmic. Often your body knows quicker than your mind.

And speed is of the essence. By this I do not necessarily mean the speed at which you are travelling. The reading on the speedometer is a small part of the story. Time and again people ask, "How fast does it go?" It's a natural question, for bikes do go fast and they can accelerate quickly. But their relation to the phenomenon and sensation of speed is more complex than a simple reckoning of their top speed.

The fastness that counts most is that between decision and consequence, between an action, which is often a reflex action, and its effect. The speed of transmission, whether this concerns direction, braking or acceleration. Other vehicles may in fact react as quickly or more quickly than a motor bike, but a jet plane, a highly tuned car, a speedboat are not as physically close to your body, and none of them leave your body so exposed. From this comes the sensation that the bike is responding as immediately as one of your own limbs—yet without your own physical energy being involved. (If your imaginative energy in the form of foresight is not involved, then heaven help you.) This immediacy bestows a sense of freedom.

Perhaps I should make clear what I mean by that. I'm not talking about leaving other people behind. It would be

dishonest to pretend that being the first away from a traffic light is not sometimes satisfying. But such a satisfaction offers only a very meagre sense of freedom. No, the freedom is between oneself and space. It touches the notion of *aim*, both spatially and subjectively.

And it is with your eyes that you first take aim. If you want to circumvent this and arrive *there*, you must look *there*, fix your eyes *there*, and you and the bike will follow. Fundamentally, you pilot neither with your arms nor your torso, but by fixing your eyes. (If you start to stare at something you wish to avoid, you will hit it.)

Your "gaze" directs you, but it is also as though what you are looking at pulls you, draws you on. The sensation of *being drawn* is visible to a third party. Watch a great rider—like Jean Michel Bayle—at a moto-cross meeting. What clearly distinguishes him from the others? It's not really his speed, nor his posture; it is simply the way he appears to allow himself to be drawn by something very far ahead. What he has fixed his eyes on is calling him. On a long drive you have the sensation of distance itself actively attracting you, drawing you in.

Much of what I've just written about choice, speed, aim, vocation, would apply in a different context, but very precisely, to the act of taking photos. Yet this does not altogether explain why I have the feeling of having arrived on a motor bike in the places photographed. We must go further.

There are those who reproach motor-cyclists for "flirting with death." It's true that the proportion of fatal accidents is higher for motor bikes than other vehicles. Yet the reproach doesn't convince me. Perhaps motor-cyclists take a certain distance from the domain of the everyday and so turn their backs temporarily on a large part of life—but it is not in order to dance with death, but rather to be unencumbered. There was once a British make of bikes called Ariel. It was an apt name. As Prospero says at the end of *The Tempest*:

how fast does it go?

. . . My Ariel, chick,
That is thy charge: then to the elements
Be free, and fare thou well. . . .

After a few hours of driving across the countryside, you
feel you have left behind more than the towns and villages
you've been through. You've left behind certain familiar con-
straints. You feel less terrestial than when you set out.

Supposing at this moment you stop, cut the engine, take
off your helmet, stretch your back and your neck, and then
walk a few paces along the road, into a wood or a field. You
look around. There's nothing spectacular or picturesque. But
you've stopped, and this already makes the spot special. Like
the spots photographed in this book.

It cannot merge with all the others to which it is so
similar. On one hand it appears to you as being familiar—a
field, or a verge of grass, or a wood, or the corner of a village,
like many thousands of others you've already seen. Yet it is
unique. You are provisionally face to face with what has been
drawing you on. You are face to face with what you were
aiming at.

Imagine the first land after a long time at sea. It is so
still, so indisputably there, so incontestably local and yet, to
the newly arrived, so foreign. Migratory birds cross thousands
of miles of ocean, leaving one continent for another, to arrive
at the same hole under the eaves of the same building they
left six months ago. Nobody is sure about how they navigate.
But when they arrive, they are sure, even the young ones
who have never made the journey before, that they have
arrived. The point of arrival is unique, and recognizable as
such.

PEOPLE TRAVEL from continent to continent to see the
Pyramids or Niagara Falls or the Amazon. Yet in one sense
they always see the same things. There's no need to go to
Canada to see the light on the spray of Niagara Falls. There's
light on water everywhere, except in the desert.

Imagine that all the basic colours, tones and shapes of
nature were fitted into a box which we were given at birth.
Some painters come to know the box almost by heart. They
empty it on to a table every time they draw or pick up a brush.
Most of us scarcely open the lid. Therefore, we are not clear
in our minds—because everything in the world looks different
and there are not even two sparrows that look alike—about
what is limited and is in the box, and what is almost infinite,
which is the number of variations possible with the contents
of the box.

Perhaps the distinction is a little similar to the relation
between the limited vocabulary of a language and what the
language may express. Yet even if we are not used to looking
into the box, everyone feels somehow that every sight is fa-
miliar, a carrier of memory. At the same time, they feel that
every sight is unique, delivering the latest urgent news that
they are alive and that the world has been created.

All this falls out when you get off the bike, take a few
steps and look at a field. Because you've broken with habit
and because you've been away and come back.

WHAT IS THE old oil drum doing in this field? It is doing
something so slowly that the something is invisible. The stains
on it, caused by some liquid, seem to recognize the rain clouds!
The light is furtive, wary of the dark from which it came.
The scrubby grass grew all this summer, drawn by the light,
but now it's stopped, like I have. Everything has turned its

back and is looking in the same direction I am—towards the opaque light in the sky behind the wood. The light of milk when you pour it into tea. Perhaps the light too which preceded everything. Is this what I came to see? There's nothing to see. It reminds me of a death. No, not really of a death, of the ordinary days that follow a death. Of every day and of procrastination.

Something similar can occur in a built-up area, if there's enough silence and stillness. A winter morning in Foussemagne. It's early. The trash hasn't been collected by the parking lot. I stopped because it was getting cold—always the hands first, however many pairs of gloves. It's not really the cold that numbs them, but their stillness. Hands weren't designed to stay still in the cold. I lock the bike and walk across the square. A tractor, with its big right wheel full of mud, passed by not long ago, for I notice the tiny clods it left along the edge of the road. On a grubby public notice-board there are posters for a sale. By the kerb two plastic sacks of garbage huddle together like a couple. Young trees are attached to their tutors. So many things here go in pairs. I begin to count them. Even the house chimneys go in pairs. And pairs suggest homes, passions, couples, births.

Yet the square in this village is as utilitarian as life can get. Maybe a man in the telephone box last night said: ". . . je mourais si tu me regarder en larmes sous la pluie."*

We shall never know, for the secrets here are indoors, inaudible and invisible. Out of doors everything visible is forgettable. Yet what is visible insists upon its presence, so I can't forget it. The forgettable cross-questions, asks again

* From a poem by Pablo Neruda, *Amours Mathilde*. Collection, *Poésie*, Paris: Gallimard).

and again with an expression that is utterly inscrutable: "So where's life?" And it goes on doing this all the time, till it gets the answer it's waiting for: "Life's here."

THE PHOTOGRAPHERS in the one hundred and one communes around Belfort did not travel on motor bikes. In their imagination they did something more difficult. They left behind aesthetic habits, the picturesque, the romantic, the exotic, and the category of the *banal*. Invariably, each one knew when he had arrived at the spot which was drawing him on. And they took their pictures, which say (as if each time the spot was the undeniable centre of the world), "You are *here*."

And here we find neither beauty nor harmony nor any of our human systems of consolation. Rather, we find indifference, entropy, desolation. (The season is winter; and there's no reason to suppose that spring was the first season!)

WE ARE NEAR TO CHAOS. But through the chaos come prophecies of an order. Is "order" the right word? I would slightly prefer "justice." And I would much prefer "love." Prophecies of a love.

An example of such a prophecy? Precisely. The prophetic creation of the visible, several billion years ago in a blind universe; the visible which is attendant today upon being seen and read.

A strange reversal occurs in these pictures. The places, photographed, face me, rather than my facing them. They seem to have been waiting during an indefinable time for the viewer's arrival. One might conclude that they were waiting for the moment (with the light just so, and the season of

winter) for the photographer to press the trigger of his camera. But this would imply that whatever was waiting, was waiting, like a film star, to be photographed. The site was simply waiting to be completed through the act of being seen. It was waiting to be recognized as visible. When we have gone, it will be incomplete again. These strange pictures are life-savers of the visible.

202

EROGENOUS
ZONE

WOMAN WITH BARE BREASTS. PAINTING BY TINTORETTO.

THE VERY LAST PERIOD of Picasso's life as a painter was dominated by the theme of sexuality. Looking at these late works, I yet again think of W. B. Yeats, writing in his old age:

> You think it horrible that lust and rage
> Should dance attention upon my old age;
> They were not such a plague when I was young;
> What else have I to spur me into song?

Yet, why does such an obsession so suit the medium of painting? Why does painting make it so eloquent?

Before attempting an answer, let us clear the ground a little. Freudian analysis, whatever else it may offer in other circumstances, is of no great help here, because it is concerned primarily with symbolism and the unconscious. Whereas the question I'm asking addresses the immediately physical and the evidently conscious.

Nor, I think, do philosophers of the obscene—like the eminent Bataille—help a great deal because, again but in a different way, they tend to be too literary and psychological for the question. We have to think quite simply about pigment and the look of bodies.

The first images ever painted displayed the bodies of animals. Since then, most paintings in the world have showed

bodies of one kind or another. This is not to belittle landscape or other later genres, nor is it to establish a hierarchy. Yet if one remembers that the first, the basic, purpose of painting is to conjure up the presence of something which is not there, it is not surprising that what is usually conjured up are bodies. It is their presence which we need in our collective or individual solitude to console, strengthen, encourage or inspire us. Paintings keep our eyes company. And company usually involves bodies.

Let us now—at the risk of colossal simplification—consider the other arts. Narrative stories involve action: they have a beginning and an end in time. Poetry addresses the heart, the wound, the dead—everything which has its being within the realm of our inter-subjectivities. Music is about what is behind the given: the wordless, the invisible, the unconstrained. Theatre re-enacts the past. Painting is about the physical, the palpable and the immediate. (The insurmountable problem facing abstract art was to overcome this.) The art closest to painting is dance. Both derive from the body, both evoke the body, both in the first sense of the word are physical. The important difference is that dance, like narration and theatre, has a beginning and an end and so exists in time; whereas painting is instantaneous. (Sculpture, because it is more obviously static than painting, often lacks colour and is usually without a frame and therefore less intimate, is in a category by itself, which demands another essay.)

Painting, then, offers palpable, instantaneous, unswerving, continuous, physical presence. It is the most immediately sensuous of the arts. Body to body. One of them being the spectator's. This is not to say that the aim of every painting is sensuous; the aim of many paintings has been ascetic. Messages deriving from the sensuous change from century to century, according to ideology. Equally, the role of gender

changes. For example, paintings can present women as a passive sex object, an active sexual partner, as somebody to be feared, as a goddess, as a loved human being. Yet, however the art of painting is used, its use begins with a deep sensuous charge which is then transmitted in one direction or another. Think of a painted skull, a painted lily, a carpet, a red curtain, a corpse—and in every case, whatever the conclusion may be, the beginning (if the painting is alive) is a sensuous shock.

He who says "sensuous"—where the human body and the human imagination are concerned—is also saying "sexual." And it is here that the practice of painting begins to become more mysterious.

The visual plays an important part in the sexual life of many animals and insects. Colour, shape and visual gesture alert and attract the opposite sex. For human beings the visual role is even more important, because the signals address not only reflexes but also the imagination. (The visual may play a more important role in the sexuality of men than women, but this is difficult to assess because of the extent of sexist traditions in modern image-making.)

The breast, the nipple, the pubis, and the belly are natural optical focii of desire, and their natural pigmentation enhances their attractive power. If this is often not said simply enough—if it is left to the domain of spontaneous graffiti on public walls—it is due to the weight of puritan moralizing. The truth is, we are all made like that. Other cultures in other times have underlined the magnetism and centrality of these parts with the use of cosmetics. Cosmetics which add more colour to the natural pigmentation of the body.

Given that painting is the appropriate art of the body, and given that the body, to perform its basic function of reproduction, uses visual signals and stimuli of sexual attraction, we begin to see why painting is never very far from the erogenous.

Tintoretto painted a canvas, *Woman with Bare Breasts*,

which is now in the Prado. This image of a woman uncovering her breast so that it can be seen is equally a representation of the gift, the talent, of painting itself. At the simplest level, the painting (with all its art) is imitating nature (with all its cunning) in drawing attention to a nipple and its aureole. Two very different kinds of "pigmentation" used for the same purpose.

Yet just as the nipple is only part of the body, so its disclosure is only part of the painting. The painting is also the woman's distant expression, the far-from-distant gesture of her hands, her diaphanous clothes, her pearls, her coiffure, her hair undone on the nape of her neck, the flesh-coloured wall or curtain behind her, and, everywhere, the play between greens and pinks so beloved of the Venetians. With all these elements, the *painted* woman seduces us with the visible means of the living one. The two are accomplices in the same visual coquetry.

Tintoretto was so called because his father was a dyer of cloth. The son, although at one degree removed and hence within the realm of art, was, like every painter, a "colourer" of bodies, of skin, of limbs.

Let us imagine this Tintoretto beside a Giorgione painting of *An Old Woman*, painted about half a century earlier. The two paintings together show that the intimate and unique relation existing between pigment and flesh does not necessarily mean sexual provocation. On the contrary, the theme of the Giorgione is the loss of the power to provoke.

Perhaps no words could ever register like this painting does the sadness of the flesh of an old woman, whose right hand makes a gesture which is so similar and yet so different from that of the woman painted by Tintoretto. Why? Because the pigment has become that flesh? This is almost true but not quite. Rather, because the pigment has become the communication of that flesh, its lament.

Finally, I think of Titian's *Vanity of the World*, which is

in Munich. There a woman has abandoned all her jewelry (except a wedding ring) and all adornment. The "fripperies," which she has discarded as vanity, are reflected in the dark mirror she holds up. Yet, even here, in this least suitable of contexts, her painted head and shoulders cry out with desirability. And the pigment is the cry.

Such is the ancient mysterious contract between pigment and flesh. This contract permits the great paintings of the Madonna and Child to offer profound sensuous security and delight, just as it confers upon the great Pietàs the full weight of their mourning—the terrible weight of the hopeless desire that the flesh should live again. Paint belongs to the body.

The stuff of colours possesses a sexual charge. When Manet paints *Le Déjeuner sur l'Herbe* (a picture which Picasso copied many times during his last period), the flagrant paleness of the paint does not just imitate, but becomes the flagrant nakedness of the women on the grass. What the painting *shows* is the body *shown*.

The intimate relation (the interface) between painting and physical desire, which one has to extricate from the churches and the museums, the academies and the lawcourts, has little to do with the special mimetic texture of oil paint, as I discuss it in my book *Ways of Seeing*. The relation begins with the act of painting, not with the medium. The interface can be there too in fresco painting or water-colour. It is not the illusionist tangibility of the painted bodies which counts, but their visual signals, which have such an astounding complicity with those of real bodies.

Perhaps now we can understand a little better what Picasso did during the last twenty years of his life, what he was driven to do, and what—as one might expect of him—nobody had quite done before.

He was becoming an old man, he was as proud as ever, he loved women as much as he ever had and he faced the

absurdity of his own relative impotence. One of the oldest jokes in the world became his pain and his obsession—as well as a challenge to his great pride.

At the same time, he was living in an uncommon isolation from the world—an isolation, as I point out in my book, which he had not altogether chosen himself, but which was the consequence of his monstrous fame. The solitude of this isolation gave him no relief from his obsession; on the contrary, it pushed him further and further away from any alternative interest or concern. He was condemned to a single-mindedness without escape, to a kind of mania, which took the form of a monologue. A monologue addressed to the practice of painting, and to all the dead painters of the past whom he admired or loved or was jealous of. The monologue was about sex. Its mood changed from work to work but not its subject.

The last paintings of Rembrandt—and particularly the self-portraits—are proverbial for their questioning of everything the artist had done or painted before. Everything is seen in another light. Titian, who lived almost as long as Picasso, painted towards the end of his life *The Flaying of Marsyas* and *The Pietà* in Venice: two extraordinary last paintings in which the paint as flesh turns cold. For both Rembrandt and Titian the contrast between their late works and their earlier work is very marked. Yet also there is a continuity, whose basis it is difficult to define briefly. A continuity of pictorial language, of cultural reference, of religion, and of the role of art in social life. This continuity qualified and reconciled—to some degree—the despair of the old painters; the desolation they felt became a sad wisdom or an entreaty.

With Picasso this did not happen, perhaps because, for many reasons, there was no such continuity. In art he himself had done much to destory it. Not because he was an iconoclast, nor because he was impatient with the past, but because

he hated the inherited half-truths of the cultured classes. He broke in the name of truth. But what he broke did not have the time before his death to be reintegrated into tradition. His copying, during the last period, of old masters like Velázquez, Poussin or Delacroix, was an attempt to find company, to re-establish a broken continuity. And they allowed him to join them. But they could not join him.

And so he was alone—like the old always are. But he was unmitigatedly alone because he was cut off from the contemporary world as a historical person, and from a continuing pictorial tradition as a painter. Nothing spoke back to him, nothing constrained him, and so his obsession became a frenzy: the opposite of wisdom.

An old man's frenzy about the beauty of what he can no longer do. A farce. A fury. And how does the frenzy express itself? (If he had not been able to draw or paint every day, he would have gone mad or died—he needed the painter's gesture to prove to himself he was still a living man.) The frenzy expresses itself by going directly back to the mysterious link between pigment and flesh and the signs they share. It is the frenzy of paint as a boundless erogenous zone. Yet the shared signs, instead of indicating mutual desire, now display the sexual mechanism. Crudely. With anger. With blasphemy. This is painting swearing at its own power and at its own mother. Painting insulting what it had once celebrated as sacred. Nobody before imagined how painting could be obscene about its own origin, as distinct from illustrating obscenities. Picasso discovered how it could be.

How to judge these late works? Those who pretend that they are the summit of Picasso's art are as absurd as the hagiographers around him have always been. Those who dismiss them as the repetitive rantings of an old man understand nothing about either love or the human plight.

Spaniards are proverbially proud of the way they can

swear. They admire the ingenuity of their oaths and they know that swearing can be an attribute, even a proof, of dignity.

Nobody had ever sworn in paint before Picasso painted these canvases.

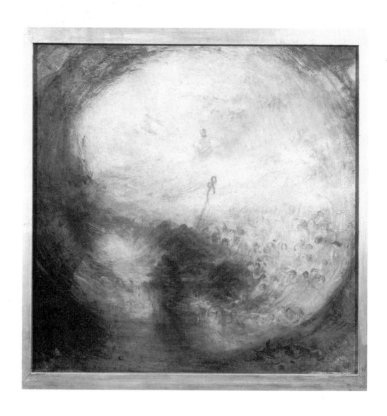

PAINTING OF *LIGHT AND COLOUR (GOETHE'S THEORY)—THE MORNING AFTER THE DELUGE*, 1843, BY TURNER.

LOST OFF
CAPE WRATH

TODAY THE DISCREDIT of words is very great. Most of the time the media transmit lies. In the face of an intolerable world, words appear to be able to change very little. State power has become congenitally deaf, which is why—but the editorialists forget it—terrorists are reduced to bombs and hijacking.

The power of reason to overthrow tyranny was, in fact, an illusion. Likewise, to believe that the pen is mightier than the sword is today a sign of relative privilege. Words are systematically used to confuse.

Yet it is with words that we confess our confusion and our impotence, our anger and our visions. With words we still name our losses and our endurance because we have no other recourse, and because people are incurably open to words and slowly they form our judgement. This judgement, which those with power habitually fear, is formed slowly, like a riverbed, by currents of words. But words only make such currents when they are profoundly credible.

I once had a dream. In the dreamt country a decree had been passed which was binding and which everybody accepted: according to this decree every word, either spoken or thought, had to be cashed for what it signified. It was as if the language and its economy had returned to the gold standard, so that every coin or bill was exchangeable for its equivalent in gold. If you thought "tree" in that country, the tree

had to appear and be there. In thinking "tree," tree became present. In thinking "morning," morning was. It was not, as in the first chapter of Genesis, a process of naming and so simultaneously creating; it was a question of speaking with *what* words meant. The words, according to the new decree, could not be left free-standing: they were porters of what they signified. All this applied not only to nouns but also to verbs, adverbs, etc. When you thought "dig," the act of digging was enacted. If you added the adverb "sadly," sadness came and was as unmistakable as salt on the lips.

For a long time in the dreamt country everybody respected the decree. As a result, there was great clarity. There was also a certain cumbersomeness because space was becoming too restricted to place everything thought and said within it. There was no confusion as before, but there was overcrowding. Tentatively people began to test what would happen if certain words weren't cashed. Could clarity be preserved more economically? At this moment the people made an unexpected discovery. As a result of the decree having been put into practice for so long, everything which existed had now become eloquent with all the words, thoughts, phrases which had ever been cashed for it. People found themselves in a *speaking* universe, in which words were no longer necessary.

A word-spinner's utopian dream! Yet buried within it is perhaps a clue about how writing becomes credible (when it does) and about the clarity of words.

One does not look *through* writing on to reality—as through a clean or dirty window-pane. Words are never transparent. They create their own space, the space of experience, not that of existence. Clarity of the written word has little to do with style as such. A baroque text can be clear; a simple one can be dim. Clarity, in my view, is the gift of the way the space, created by words in a given text, is arranged.

The task of arranging this space is not unlike that of furnishing and arranging a home. The aim is similar: to accommodate with ease what belongs there and to welcome those who enter. There are hospitable and inhospitable writings. Hospitality and clarity go together. Yet what does "accommodate" mean here? It means allowing each event recounted its own proper space. By "event" I mean what would become present if the words were cashed. In semiological jargon: the signified. The space required is not of course physical. A scarf may demand more space than a cloud. Everything depends upon the particular experience being recounted.

Lived events are ambiguous because no experience comes alone and so a single event entails many others. A lived event—from the point of the purist—keeps bad company, is promiscuous. This is perhaps where the principal difference between science and art begins.

Let us take an extremely simple example of ambiguity in the practice of narration. *The ship sailed out of the port.* An adventure or a farewell? From the quayside the mood is passive; from the stern of the ship it is active. The ensuing words will remove certain ambiguities and, at the same time, will entail other, new ones. *He looked towards the horizon.* An act of will, an act of habit? *The screeching gulls reminded him of his father, lost off Cape Wrath.*

Each event, each object needs to be allowed the space of its ambiguities, and each subsequent one needs to acknowledge the ambiguities it has eliminated.

The father's death "acknowledges" the ship's sailing away. The suggestion that the father was a sailor or a fisherman "acknowledges" the son's looking at the horizon. An unspoken dialogue is taking place between the events. The problem of narration is not, as is often believed, the problem of "finding the words," but that of choosing and placing

events, of allowing or instigating their wordless dialogue. The complexity of choices involved, when they concern a whole text, would defeat the most sophisticated computer, because it could never be adequately programmed. The writer, programmed by his experience of life and of the inarticulate, accommodates intuitively, rarely by calculation. He becomes his own writing's instinct of self-preservation: an instinct applied to keeping open the space for reciprocal ambiguities without end.

The moment the writer's attention is diverted by considerations of style, rhetoric or verbal glory, his words, instead of containing, will merely evoke. The moment he simply repeats facts instead of imagining the experience of them, his writing will be reduced to a document.

The credibility of words involves a strange dialectic. It is the writer's openness to the ambiguity and uncertainty of any experience (even the experience of determination and certainty) which gives clarity, and thus a kind of certitude, to his writing. He has to abjure words so that, abandoned, they join the "object," the narrated event, which then becomes eloquent with them. The country in my dream was, in fact, literature.

Authenticity in literature does not come from the writer's personal honesty. There have been great writers who were mythomaniacs. Writers in general break their word at least as often as most other sedentary people. Moreover, many writers—not all—are excessively egocentric, blind to everything that turns its back on them. The disappointment of readers on meeting an admired writer probably begins with this confusion about the source of authenticity. It has little to do with either honesty or wisdom; still less with a devotion to beauty or to aesthetics. All "beautiful" writing is dim. Authenticity comes from a single faithfulness: that to the ambiguity of experience. Its energy is to be found in how one

event leads to another. Its mystery is not in the words but on the page.

Recently, a new book of mine came out. I received the first copy from the publishers. It was so badly designed, so grubbily laid-out, and so carelessly produced that the sight of it, instead of affording a small pleasure was sad and discouraging—like dirty clothes can sometimes be. My son Jacob was with me and we decided to burn it.

We dropped the book into the wood stove which was heating the kitchen. Outside, it was snowing. A few minutes later, far from discouraged, we were watching it burn. The lines of print, the black words turned white, whiter than the paper. Then an entire page became uniformly incandescent, and radiant with energy. The pages burning were like ideal pages being written.

The writer should be informed to the maximum about what he is writing. In the modern world in which thousands of people are dying every hour as a consequence of politics, no writing anywhere can begin to be credible unless it is informed by political awareness and principles. Writers who have neither produce utopian trash. The unpardonable perversity of our *fin de siècle* is that of its innocence.

If I speak of mystery, it is not to encourage mystification or cultivated naivety, but only to suggest that the credibility of writing—and hence its force—derives from a wordless acknowledgment of mystery. Most words applied directly to mysteries are either cant (to defend some power or privilege) or sincere yet unconvincing.

If a writer is not driven by a desire for the most demanding verbal precision, the true ambiguity of events escapes him. The amorphous does not require accommodation; it simply fills the room (or book) like a gas. He can only abjure words when he has asked too much of them. And at that moment the ambivalent eloquence of the event saves him.

2 1 7

When his pages are finished, the reciprocal ambiguities coalesce into a mystery. Mystifications protect power. Mysteries protect the sacred. Any writer whose writing possesses the credibility I am talking about has been moved by the simple conviction that life itself is sacred. This is the starting point.

A DIFFERENT ANSWER

THE ARAN ISLANDS. PHOTO BY JOHN BERGER.

I TRAVELLED NOT LONG AGO to the four corners of Europe—except that Europe, not being square, has more than four corners. I went to northern Finland, to the start of the Anatolian plains east of Istanbul, to the *meseta* in Spain, and to the Outer Hebrides. In each corner of the continent the substances of the centre, the stuff of life as lived in the centre, are rare. Yet to say that the corners are poor would be to miss the point. In the corner-pockets there's simply a change of currency. Each corner belongs to a way of living with nature and other people which is elsewhere. Not there. Not here. But persistently elsewhere.

For example, in northern Finland there's scarcely any soil. Everything is water, sky or two kinds of tree. As a result you have the impression, coming from the centre, that it is all continually disappearing. You look up and whatever was there has gone! Slipped off. A second before.

The remoteness of the corners is only partly explained by latitude or climate. It's at least as much to do with time. Centres generate the future—or at least this is what our continent believed for a couple of centuries. The periphery was where the past ended up. Victors captured the centre. The vanquished retreated to the edge. In the centres blazed arc-lights. On the edges there remained only a diffused Celtic—or Anatolian—glow.

a different answer

Yet now there are signs that the centres are losing their historical initiative. They no longer announce the future, or, if they do, they are no longer altogether believed. Maybe this is why, in the four corners of Europe, I had the impression not of escaping but of facing up to certain questions usually avoided.

The island Barra, which covers an area of thirty-five square miles, is the shape of a sole being bread-crumbed: the bread crumbs are sand. The sand on the western Atlantic side is pale, and scrubby alfalfa grass, pushing here and there through the dunes, reminds you of the Sahara without the sun. As hard to think of the Sahara without the sun as it is to think of Barra without the sea.

Into this Atlantic sand the feet sink quite deep. Even a small dog's paws would go in half an inch. But it easily supports the ringed plovers that run left, centre and sideways across it, dipping their heads for food and puncturing the surface with tiny holes no larger than the lead of the smallest pencil.

The sand on the eastern side of the island is shell-sand, greyer and very hard, hard enough for a plane from the mainland to land on the beach by the airport, when the tide is out. The plane comes down on to the wet sand, pitted with worm casts, and, further out, men dig for cockles. The sky there is an immense balcony facing west, from where the light changes every five minutes. With the light, the colour of the shell-sand changes too, like mother-of-pearl.

Homer talks of the "harvestless sea," as if the sea were barren. Maybe this was because the Aegean Islands could produce oil and wine, vegetables and cereals. Here the islands can produce so little that it is the sea which promises life and energy, not the land. The sheep graze and the sea roars. Tufts of wool, caught on barbed wire, are blown away in the

221

wind like detritus. The waves wear lace. The rollers coming in from the Atlantic never stop their delivery, and the land cannot keep what is delivered.

Nobody has described Atlantic isles better than the great Irish playwright J. M. Synge. He had an ear for the sea as fine as his ear for language. This is from the journal he kept on the Aran Islands, which can be found on exactly the same longitude as Barra, two or three hundred miles to the south.

I have been down sitting on the pier till it was quite dark. I am only beginning to understand the nights of Inishmaan and the influence they have had in giving distinction to these men who do most of their work after nightfall.

I could hear nothing but a few curlews and other wild-fowl whistling and shrieking in the seaweed, and the low rustling of the waves. It was one of the dark sultry nights peculiar to September, with no light anywhere except the phosphorescence of the sea, and an occasional rift in the clouds that showed the stars behind them.

The sense of solitude was immense. I could not see or realise my own body, and I seemed to exist merely in my perception of the waves and of the crying birds, and of the smell of seaweed.

When I tried to come home I lost myself among the sand hills, and the night seemed to grow unutterably cold and dejected, as I groped among slimy masses of seaweed and wet crumbling walls.

After a while I heard a movement in the sand, and two grey shadows appeared beside me. They were two men who were going home from fishing. I spoke to them and knew their voices, and we went home together.

There are only a few trees on the island where the fall of the land offers some shelter from the winds. From most vantage points Barra looks shorn. There are not even bushes. Only stone walls. The wind takes the island between its knees and, like the men do to the sheep, it shears. Day and night.

Off Barra, seals swim in the bays. According to an old ruling of the Church—for it is a predominantly Catholic island—seals should not be eaten on Friday because they constitute meat, though living in the sea. "Why, Father?" "Because seals, my son, as no fish do, break wind like animals!"

It is difficult to imagine any man born here, before the planes came, not becoming a fisherman or a sailor. It is hard to imagine any woman not also being married to the sea. The sea is the only promise which is kept. It promises that no danger is lurking in its troughs or crests but only where it breaks on land or rock. It promises endless departures and a few fish. The ocean is the bethrothed. For here nothing represents life more than the ocean. And in the end it takes all. "They're all gone now," says the old mother in one of Synge's marvellous plays, "they've gone now, and there isn't anything more the sea can do for me. . . . I'll have no call now to be up crying and praying when the wind breaks from the south, and you can hear the surf is in the east, and the surf is in the west, making a great stir with the two noises, and they hitting one on the other. . . ."

From the top window of any house you can see gannets plummet to spike mackerel, entering, all their feathers swept back, the hole in the water they've made with their beaks. Gales, showers, squalls, sunshine. Rainbows arching several times a day. The crabs four hundred million years old.

When you look up at the balcony of the sky from Barra,

another answer comes to one of the oldest questions—a different answer to the one given in the Age of Enlightenment. With things changing every hour, and for ever repeating themselves like the tide, you understand that the Creation, for all its beauty, was begun out of suffering.

THE SOUL AND THE OPERATOR

THE PHOTOS come from Warsaw, Leipzig, Budapest, Bratislava, Riga, Sofia. Every nation has a slightly different way of physically standing shoulder to shoulder during mass demonstrations. But what interests me in all the photos is something that is invisible.

Like most moments of great happiness, the events of 1989 in Eastern Europe were unforeseeable. Yet is happiness the right word to describe the emotion shared by millions that winter? Was not something graver than happiness involved?

Just as the events were unforeseeable, so still is the future. Would it not be more apt to talk of concern, confusion, relief? Why insist upon happiness? The faces in the photos are tense, drawn, pensive. Yet smiles are not obligatory for happiness. Happiness occurs when people can give the whole of themselves to the moment being lived, when Being and Becoming are the same thing.

As I write, I remember leaving Prague in a train more than twenty years ago. It was as if we were leaving a city in which every stone of every building was black. I hear again the words of a student leader, who stayed behind, as he addressed the last meeting: "What are the plans of my generation for this year of 1969? To pursue a current of political thought opposed to all forms of Stalinism, and yet not to indulge in dreams. To reject the utopia of the New Left, for with such dreams we could be buried. To maintain somehow

our links with the trade unions, to continue to work for and prepare an alternative model of socialism. It may take us one year, it may take us ten. . . ."

Now the student leader is middle-aged. And Dubček is the prime minister of his country.

Many refer to what is happening as a revolution. Power has changed hands as a result of political pressure from below. States are being transformed—economically, politically, juridically. Governing élites are being chased from office. What more is needed to make a revolution? Nothing. Yet it is unlike any other one in modern times.

First because the ruling élite (except in the case of Romania) did not fight back, but abdicated or reneged, although the revolutionaries were unarmed. And secondly, because it is being made without utopian illusions. Made step by step, with an awareness that speed is necessary, yet without the dreaded classic exhortation of *Forward!*

Rather, the hope of a return. To the past, to the time before all the previous revolutions? Impossible. And it is only small minorities who demand the impossible. These are spontaneous mass demonstrations. People of every generation, muffled up against the cold, their faces grave, happy, keeping a rendezvous. With whom?

Before answering, we have to ask what is it that has just ended? The Berlin Wall, the one-party system, in many countries the Communist Party, the Red Army occupation, the Cold War? Something else which was older than these and less easy to name has also ended. Voices are not lacking to tell us what it is. History! Ideology! Socialism! Such answers are unconvincing, for they are made by wishful thinkers. Nevertheless, something vast has ended.

Occasionally, history seems to be oddly mathematical. Last year—as we were often reminded—was the two hundredth anniversary of the French Revolution, which, al-

though not the first, became the classic model for all other modern revolutions. 1789–1989. Sufficient to write down these dates to ask whether they do not constitute a period. Is it this that has ended? If so, what made this a period? What was its distinguishing historical feature?

During these two centuries the world was "opened up," "unified," modernized, created, destroyed and transformed on a scale such as had never occurred before. The energy for these transformations was generated by capitalism. It was the period when self-interest, instead of being seen as a daily human temptation, was made heroic. Many opposed the new Promethean energy in the name of the General Good, of Reason and of Justice. But the Astheans and their opponents had certain beliefs in common. Both believed in Progress, Science, and a new future for Man. Everyone had their particular personal set of beliefs (one reason why so many novels could be written) but in their *practice*, their traffic with the world, their exchanges, all were subject to systems based exclusively on a materialist interpretation of life.

Capitalism, following the doctrines of its philosophers—Adam Smith, Ricardo and Spencer—installed a practice in which only materialist considerations and values counted. Thus the spiritual was marginalized; its prohibitions and pleas were ruled out of court by the priority given to economic laws, laws given the authority (as they still have today) of natural laws.

Official religion became an evasive theatre, turning its back on real consequences and blessing principally the powerful. And in face of the "creative destruction" of capitalism—as Joseph Schumpeter, one of its own eminent theorists, defined it—the modern rhetoric of bourgeois politics developed, so as to hide the pitiless logic of the underlying practice.

The socialist opposition, undeceived by the rhetoric and hypocrisy, insisted upon the practice. This insistence was

Marx's genius. Nothing diverted him. He unveiled the practice layer by layer until it stood exposed once and for all. The shocking vastness of the revelation gave prophetic authority to historical materialism. Here was the secret of history and all its sufferings! Everything in the universe could now be explained (and resolved!) on a material basis, open to human reason. Egoism itself would eventually become outdated.

THE HUMAN IMAGINATION, however, has great difficulty in living strictly within the confines of a materialist practice or philosophy. It dreams, like a dog in its basket, of hares in the open. And so, during these two centuries, the spiritual persisted, but in new, marginalized forms.

Take Giacomo Leopardi, who was born in exactly the year our period opens. He was to become Italy's greatest modern lyric poet. As a child of his time, he was a rationalist of the existent and studied the universe as a materialist. Nevertheless, his sadness and the stoicism with which he bore it, became, within his poetry, even larger than the universe. The more he insisted on the materialist reality surrounding him, the more transcendent became his melancholy.

Likewise, people who were not poets tried to make exceptions to the materialism which dominated their epoch. They created enclaves of the *beyond*, of what did not fit into materialist explanations. These enclaves resembled hiding-places; they were often kept private. Visited at night. Thought of with bated breath. Sometimes transformed into theatres of madness. Sometimes walled in like gardens.

What they contained, the forms of the *beyond* stored away in these enclaves, varied enormously according to period, social class, personal choice, and fashion. Romanticism, the Gothic revival, vegetarianism, Rudolf Steiner, art for art's

sake, theosophy, sport, nudism. . . . Each movement saved for its adepts fragments of the spiritual which had been banished.

The question of fascism, of course, cannot be avoided here. It did the same thing. Nobody should presume that evil has no spiritual power. Indeed, one of the principal errors of the two centuries concerned evil. For the philosophical materialists the category was banished, and for the rhetoricians of the establishment evil became Marxist materialism! This left the field wide open for what Kierkegaard correctly called the prattle of the Devil, the prattle that erects a terrible screen between name and thing, act and consequence.

Yet the most original marginalized spiritual form of the period was the transcendent yet secular faith of those struggling for social justice against the greed of the rich. This struggle extended from the Club des Cordeliers of the French Revolution to the sailors in Kronstadt to my student friends in the University of Prague. It included members of all classes—illiterate peasants and professors of etymology. Their faith was mute in the sense that it lacked ritual declaration. Its spirituality was implicit, not explicit. It probably produced more acts of willing self-sacrifice, of nobility (a word from which some might have shrunk) than any other historical movement of the period. The explanations and strategies of the men and women concerned were materialist; yet their hopes and the unexpected tranquility they sometimes found in their hearts were those of transcendent visionaries.

To say, as is often said, that communism was a religion is to understand nothing. What counted was that the material forces in the world carried for millions—in a way such as had never happened before—a promise of *universal* salvation. If Nietzsche had announced that God was dead, these millions felt that he was hiding in history and that, if together they could carry the full weight of the material world, souls would

again be given wings. Their faith marked a road for mankind across the usual darkness of the planet.

Yet in their socio-political analyses there was no space for such faith, so they treated their own as an illegitimate but loved child who was never given a name. And here the tragedy began. Since their faith was unnamed, it could easily be usurped. It was in the name of their determination and their solidarity that the party-machines justified the first crimes, and, later, the crimes to cover up further crimes, till finally there was no faith left anywhere.

SOMETIMES, because of its immediacy, television produces a kind of electronic parable. Berlin, for instance, on the day the Wall was opened. Rostropovich was playing his cello by the Wall that no longer cast a shadow, and a million East Berliners were thronging to the West to shop with an allowance given them by West German banks! At that moment the whole world saw how materialism had lost its awesome historic power and become a shopping list!

A shopping list implies consumers. And this is why capitalism believes it has won the world. Chunks of the Berlin Wall are now being sold across the world. Forty marks for a large piece from the Western side, ten marks for a piece from the Eastern side. Last month the first McDonald's opened in Moscow; last year the first Kentucky Fried Chicken in Tiananmen Square. The multinationals have become global in the sense that they are more powerful than any single nation state. The free market is to be installed everywhere.

Yet if the materialist philosophy of the last two centuries has run out, what is to happen to the *materialist fantasy* on which consumerism and therefore global capitalism is now utterly dependent?

Marketing punctuates our lives as regularly and systematically as any prayer cycle in a seminary. It transfigures the product or package being sold so that it gains an aura, wins a radiance, which promises a kind of temporary immunity from suffering, a sort of provisional salvation, the salutary act always being the same one of buying. Thus any commodity becomes a way of dreaming, but, more importantly, the imagination itself becomes acquisitive, accepting the credo of Ivan Boesky addressing graduates at Berkeley business school: "I think greed is healthy. You can be greedy and still feel good about yourself."

The poverty of our century is unlike that of any other. It is not, as poverty was before, the result of natural scarcity, but of a set of priorities imposed upon the rest of the world by the rich. Consequently, the modern poor are not pitied—except by individuals—but written off as trash. The twentieth-century consumer economy has produced the first culture for which a beggar is a reminder of nothing.

MOST COMMENTATORS on the events in Eastern Europe emphasize the return to religion and nationalism. This is part of a world-wide tendency, yet the word "return" may be misleading. For the religious organizations in question are not the same as they previously were, and the people who make up this "return" are living with transistors at the end of the *twentieth* century, not the eighteenth.

For example, in Latin America it is a branch of the Catholic Church (much to the pope's embarrassment) which today leads the revolutionary struggle for social justice and offers means of survival to those being treated as historical trash. In many parts of the Middle East the growing appeal of Islam is inseparable from the social conscience it promises on behalf

of the poor, or (as with the Palestinians) the landless and the exiled, up against the remorseless economic and military machinery of the West.

The resurgent nationalisms reflect a similar tendency. Independence movements all make economic and territorial demands, but their first claim is of a spiritual order. The Irish, the Basques, the Corsicans, the Kurds, the Kosovans, the Azerbaijanis, the Puerto Ricans and the Latvians have little in common culturally or historically, but all of them want to be free of distant, foreign centres which, through long, bitter experience, they have come to know as soulless.

All nationalisms are at heart deeply concerned with names: with the most immaterial and original human invention. Those who dismiss names as a detail have never been displaced; but the peoples on the peripheries are always being displaced. This is why they insist upon their identity being recognized, insist upon their continuity—their links with their dead and the unborn.

If the "return" to religion is in part a protest against the heartlessness of the materialist systems, the resurgence of nationalism is in part a protest against the anonymity of those systems, their reduction of everything and everybody to statistics and ephemerality.

Democracy is a political demand. But it is something more. It is a moral demand for the individual right to decide by what criteria an action is called right or wrong. Democracy was born of the principle of conscience. Not, as the free market would today have us believe, from the principle of choice which—if it is a principle at all—is a relatively trivial one.

THE SPIRITUAL, marginalized, driven into the corners, is beginning to reclaim its lost terrain. Above all, this is happening in peoples' minds. The old reasoning, the old common sense, even old forms of courage have been abandoned, and unfamiliar recognitions and hopes, long banished to the peripheries, are returning to claim their own. This is where the happiness behind the faces in the photo starts. But it does not end there.

A reunion has occurred. The separated are meeting—those separated by frontiers and by centuries. Throughout the period which is ending, daily life, with all its harshness, was continually justified by promises of a radiant future. The promise of the new Communist man for whom the living were ceaselessly sacrificed. The promise of science forever rolling back the frontiers of ignorance and prejudice. More recently, the promise of credit cards buying the next instant happiness.

This excessive need of a radiant future separated the present from all past epochs and past experience. Those who had lived before were further away than they had ever been in history. Their lives became remote from the unique exception of the present. Thus for two centuries the future "promise" of history assured an unprecedented solitude for the living.

Today the living are remeeting the dead, even the dead of long ago, sharing their pain and their hope. And, curiously, this too is part of the happiness behind the faces in the photos.

How long can this moment last? All the imaginable dangers of history are waiting in the wings—bigotry, fanaticism, racism. The colossal economic difficulties of ongoing everyday survival are, in theory, going to be solved by the free market. With such a market comes the risk of new ravenous appetites for money, and with their voraciousness jungle law. But nothing is finally determined. The soul and the operator have come out of hiding together.

NAPALM 1991

KUWAIT 1991.

Mother let me cry
not letterpress
nor telex
nor stainless speech—
bulletins
announce disaster
with impunity—
but the pages of the wound.

Mother let me speak
not adjectives
to color
their maps of wretchedness
nor nouns to classify
the families of pain—
but the verb of suffering.

Our mother tongue taps
the sentence
on the prison wall.
Mother let me carry
the voices
howling in the falls.

Illustration Credits

About the Author

JOHN BERGER was born in London in 1926. He is well known for his novels and stories as well as for his works of nonfiction, including several volumes of art criticism. His first novel, *Painter of Our Time*, was published in 1958, and since then his books have included the novel *G.*, which won the Booker Prize in 1972.

This is his sixth volume collection of essays, the others including *The Sense of Sight* (1985), *About Looking* (1980) and *Ways of Seeing* (1972).

With *Lilac and Flag* (1990) Berger completed his present trilogy *Into Their Labours*, the first two volumes of which were *Pig Earth* (1979) and *Once In Europa* (1987).

In 1962 Berger left Britain permanently, and he now lives in a small peasant village in the French Alps.